THE
SANDUSKY
MALL

D1523373

THE
SANDUSKY
A HISTORY
MALL

CHRIS BORES

THE
History
PRESS

Published by The History Press
Charleston, SC
www.historypress.com

Copyright © 2021 by Chris Bores
All rights reserved

Front cover, top left: Julie Hamilton; *top center*: Linda Howell; *top right*: Paul Smith; *bottom left*: Sandusky Library; *bottom right*: Sheila Franklin. *Back cover, top*: Jason McFarlin; *middle: Lauren Dee*; *bottom*: Joe Bell.

First published 2021

Manufactured in the United States

ISBN 9781467149563

Library of Congress Control Number: 2021945858

CONTENTS

PREFACE

The shopping mall of yesterday is quickly becoming a piece of nostalgic American history. From the atmosphere, to the architecture, down to the color pallet of groovy retro colors, shopping at a mall in the 1970s and '80s was quite an experience. It was a time when mall owners and architects took rewarding risks that brought a special charm to each and every mall that was built. The charm brought to the Sandusky Mall was the larger-than-life water fountains with huge Tiffany-style stained-glass lights above them.

Sadly, when I head to a mall today, it's a very sterile experience. I try to explain to my kids how cool going to the mall used to be, and I just can't do it justice. They don't understand. Malls have been transformed into cookie-cutter buildings with the same stores and no identity. It's as if a Skeksis from the movie *Dark Crystal* was physically manifested by corporatism and drained the life essence out of these facilities over the last few decades. During the 1990s, mall owners kept raising prices to bring in big-box store names, squeezing out the little guys, who had been able to bring that taste of originality into each mall. Back then, malls were filled with arcades, toy stores, newsstands, comic book stores, record stores, snack shops, hair salons and more. Today, those types of stores are long gone. Malls are closing all over the country because of it. Sure, you could blame online shopping, but I also argue that malls squeezed out the smaller stores that gave people a reason to visit them in the first place.

Thankfully, we have reached that point in time when malls have become nostalgic to adults who grew up in the 1970s and '80s. In fact, the idea of writing this book came to me while watching the popular Netflix show *Stranger Things*. Most of the show's third season took place at the local mall in the 1980s. What really struck me was how well the mall was portrayed. It was bright and colorful and captured the '80s mall vibe perfectly. Whenever I brought this topic up with my friends, the conversation would last hours as we tried to remember all the stores that existed in our mall. After many of these conversations, I knew I had to do this book. Even when I told random people I was working on this book, I saw a level of interest that I've never seen before, especially from people who didn't even buy books! So I knew that writing this was a no-brainer.

I never thought I'd be doing a history book on the Sandusky Mall, but here we are. What's even odder is that no one has done a history about a mall, ever. Period. So, to take on such a task was a bit overwhelming. I spent a lot of time in the beginning thinking about how to lay out a book like this. Since it had never been done before, I had to create my own template from scratch. I wanted to be able to capture the small universe that existed inside the mall while covering all the stores within it. I wanted to be able to revisit how I ate lunch at the Woolworth Café, bought those weird Battle Beasts toys at Circus World, headed to Cole Books to pick up the latest Garfield comic strip collection, walked to Gray Drugs to rifle through its comic book offerings, spent all my quarters playing video games at Gold Mine or watched *Star Trek VI* at the Mall Cinema with my childhood friend. Every store had a purpose, and I wanted to make sure each one was included.

As I spent months pulling this book together, it was weird to think how I spent so much time in a place that doesn't even exist that way anymore. I recently lost my father. There were many times I would be writing about a long-defunct store and a random memory involving both of us in that location would pop into my mind. I'd sit back and think, "Wow, both the store and my dad are forever locked in another time period." It was bittersweet. So I hope that this book elicits great memories for everyone who reads it.

I tried very hard to get everything within these pages as historically accurate as possible. I pored through thousands of newspapers and talked to hundreds of people to verify store locations and get the mall map just right. I can't tell you how many hours I labored over that damn mall map! No detailed floor plan from the 1970s or '80s was ever preserved for public consumption. I spent months cross-referencing every location's placement and battling through dozens of foggy memories to get everything right. Thankfully,

small fragments of information came to me almost serendipitously, and I'm confident that everything is as accurate as humanly possible. You'll notice that I focused on the first ten or so years on stores that entered the mall. This is because, by the 1990s, stores opened and closed quickly. It would have been a nightmare to keep track of them all.

In closing, I can't thank you enough for picking up this book. It is the culmination of my love of the 1980s. It was such a joy to be wrapped up in a little chuck of space and time that existed in the 1970s and '80s. It is time to bring it back to life.

1

MAIN STREET TO MILAN ROAD

As a kid growing up in the 1980s, I would look at early Sandusky history books and wonder how the main retail hub shifted from downtown to Milan Road. Those books would cut off around the turn of the twentieth century and not answer that question. There was this huge portion of history that no one covered in book form. After researching things for myself, I found that it didn't happen overnight. It was a slow and gradual shift. The whole story is rather interesting, and I feel it needs to be told as a pretext for how the mall ended up in Sandusky in the first place.

In the early 1900s, if you wanted to go shopping in Sandusky, you had to travel downtown, as everything was centralized around Columbus Avenue. Anything that a homeowner could want was usually placed within proximity of the shopping stores there. Even homes were built close to each other, with little yard space around them. This was because everyone wanted to live as close to downtown as possible.

By the 1950s, Sandusky had brought in many popular department stores to occupy downtown. Most of them had been there since the turn of the twentieth century. These included J.C. Penney, Woolworth, Sears, Kresge and LaSalle's, among others. This was the way of things for many years, until the end of the 1950s, when lifestyle shifts began to ripple through society. That decade saw the explosion of automobile sales as the mantra of the American Dream shifted to "every family having a car in every garage." Sandusky had received two car-manufacturing plants (Ford and GM), and many people working at these factories were able to earn incomes well over

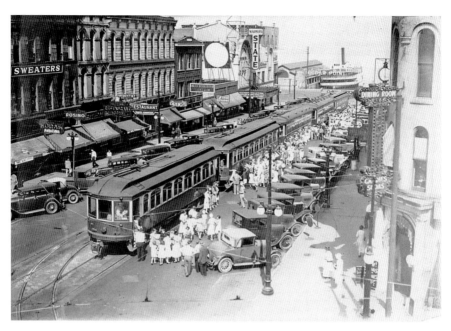

Downtown Sandusky, 1931. *Sandusky Library.*

the national average. As families began making more money, they began wanting larger homes with big yards. All eyes turned to the countless acres of uncultivated farmland just outside the city limits. No longer did factory workers have to live downtown in houses packed close together. They could build new homes that mirrored the 1950s version of the American Dream, including big backyards, picket fences, a modern kitchen and, yes, a car in the garage. Owning an automobile gave families the freedom to live on the outskirts of town and not be reliant on the trollies that operated downtown. You could easily drive to work every day, no matter where you lived. If it was good enough for the Beach Boys' "Little Old Lady from Pasadena," it was good enough for the blue-collar worker.

The trend of families moving out of downtown was known at the time as "urban sprawl." It was an exodus that was happening countrywide. Before long, contractors were building huge clusters of new homes all along Cleveland Road and Perkins Avenue. The number of homes per capita began surging in several area locations, attracting the attention of high-stakes business owners from the Cleveland area.

By 1956, shopping centers were taking hold in the northern Ohio area, thanks to William Cafaro and his company, Cafaro Co. The Youngstown-

based firm capitalized on urban sprawl and built shopping plazas throughout Cleveland's suburban areas. As Sandusky continued to grow, William set his sights on a plot of land along Cleveland Road where the sprawl was most concentrated. He built a brand-new shopping plaza.

To bring this project to life, Cafaro approached many big-name stores in the downtown area. His proposal was a juicy one, as he offered larger retail spaces with plenty of free parking. This was enticing, as many downtown stores were struggling with the limited square footage the buildings gave them. The 1950s gave birth to many new "must-have" home innovations, like modern ovens, refrigerators, washing machines, floor sweepers and televisions. Finding enough room to place these new items on an already crowded sales floor was getting tougher by the year.

Despite the appealing offer, moving out of downtown was an incredible risky venture. Since shopping plazas were a new concept, no one knew if the idea would flop or not. In the end, Cafaro managed to wrangle a few tenants from downtown Sandusky, like Moore's Store and Cohn's. Woolworth also signed on, but instead of leaving downtown, it opted to build a second location in the Sandusky Plaza.

On November 1, 1956, the Sandusky Plaza opened with a huge ribbon-cutting celebration for all twenty businesses located inside. The roadside plaza would contain two larger "anchor stores" to bring the foot traffic in, while the other stores piggybacked off them. The other smaller stores included Gray Drug, Pick N Pay, Howard Johnson, Sloane Bar and Grill, Lee's Barber Shop, Cleveland Fabric Shop, Plaza Hardware, Sterling Carpet, Norman Shoe Store, Zuckers Store for Men, W.T. Grant Company,

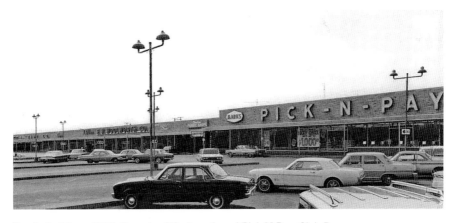

Sandusky Plaza, 1957, featuring Woolworth and Pick N Pay. *Chris Bores*.

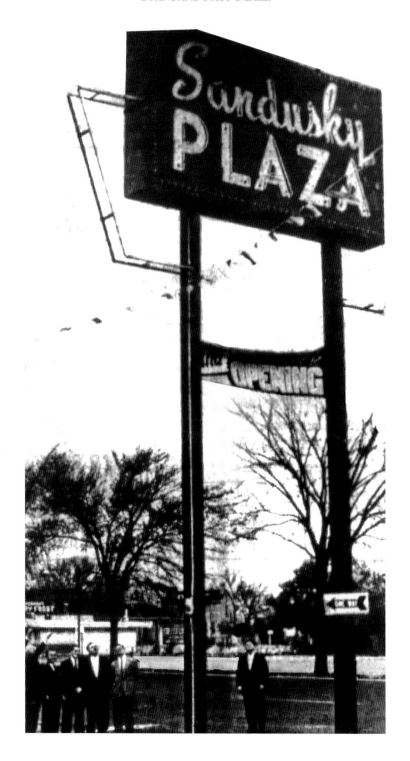

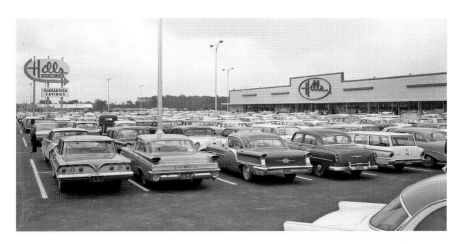

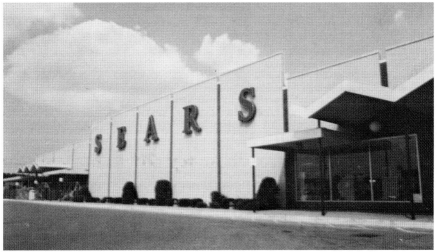

Opposite: Sandusky Plaza's grand opening, 1956. *Sandusky Library*.

This page, top: Hills Department Store in Perkins Plaza, 1963. *Sandusky Library*.

This page, bottom: Sears Department Store in Perkins Plaza, 1966. *Jason McFarlin*.

Thom McAn, Van Clear Silk, Plaza Meats, French Tex Cleaners and the area's first Kroger store.

To everyone's surprise, the Sandusky Plaza exploded right out of the gate. People had no problem adapting to shopping at a plaza outside of downtown. Cafaro's plaza was so successful that, five years later, his company built another shopping plaza on the other side of town, where urban sprawl was also prevalent. On August 14, 1963, Perkins Plaza

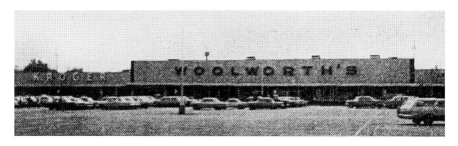

Kroger and Woolworth in the Perkins Plaza 1966. *Sandusky Library.*

opened off Perkins Avenue. This time, Hills Department Store was brought in as the main anchor store, alongside Lee's Barber Shop, Ann's Sweet Shoppe and French Tex. Hills had been expanding all over northeast Ohio and made a deal with Cafaro to finally enter the Sandusky market. From day one, Hills made quite the impact. It had over sixty thousand square feet of retail space and had seventy-four departments in all.

Two years later, Cafaro Co. announced that another major tenant would be coming to Perkins Plaza. This time, they pulled away Sears Department Store, a longtime staple of downtown. Sears joined Hills on the opposite end of the plaza. This new location gave Sears more than four times the retail space, to 160,000 square feet.

With Sears and Hills becoming retail plaza buddies, they became a fierce competitor to the downtown department stores. After Sears pulled out, Pick N Pay and Woolworth also came to the plaza, in 1966.

One of the interesting projects that helped keep the downtown businesses afloat was the construction of the Route 2 interstate, which was being built throughout Ohio. As fate would have it, the new highway ran through Sandusky, which helped put the stores back on the map. The project, which began in 1962 and finished in 1968, was born out of the Interstate Highway Act, signed by Dwight D. Eisenhower in 1956. Costing $22 million, the project would connect a main interstate road from Toledo to Cleveland. This would also connect all of the major roads leading into Sandusky's downtown area—Route 6, Route 4 and Route 250. It was a project that proved beneficial for tourists navigating around Sandusky. Because of the new interstate, Cedar Point began upgrading its amusement park. It wasn't long before Sandusky city officials also began considering what they could add to downtown that would help drum up business. It all started with the idea of a shopping mall.

2

BUILD THAT MALL!

The city of Sandusky was rapidly growing by the end of the 1960s. The city had four shopping plazas, a newly installed Route 2 and an amusement park that was restructuring to become the ultimate tourist spot right off the new interstate. In the fall of 1969, the Sandusky City Board met and began throwing various ideas around to revitalize downtown. The biggest and most ambitious idea was the proposal of building a shopping mall.

The first modern-day enclosed shopping mall was built in 1956 in Edina, Minnesota. By the 1970s, the concept had caught on; malls were being built in many high-population areas right off the new interstates. From California to New York, they were becoming all the rage, especially with the youth. The idea of placing one hundred retail stores under one roof brought a whole new experience to shoppers. Hundreds of shops could be lined up side by side along both sides of a hallway for maximum access. These enclosed buildings also featured a climate-controlled environment. With Ohio having some of the harshest summers and winters in the country, this feature was an absolute must for shoppers. Each mall built around the country was usually given some architectural flare that made it unique. These included amazing water-fountain layouts, huge murals on the ceiling and other displays featuring plants or artwork.

On November 26, 1969, city officials met in the halls of the Sandusky Chamber of Commerce to determine if building a shopping mall downtown was even feasible. Hopes ran high as the group clicked through a carousel

Perkins Plaza now includes Sears and Hills department stores. *Jason McFarlin*.

of picture slides on a film project of various malls across the country. When it came time to figure out where they could place their own shopping mall, they had only one option. It was an area that stretched between Market and Washington Streets where LaSalle's was located. Try as they might, the proposal couldn't hold water and fell apart quickly. They knew that parking and traffic issues would create a nightmare scenario downtown, as parking was already an issue with current businesses. Adding a huge shopping mall would only make matters worse.

The downtown plans were scrapped. Even though the proposal failed, the idea of a shopping mall entering the Sandusky area never subsided. By 1971, mall fever was gripping many people. As fate would have it, William Cafaro from Cafaro Co. had already built a handful of malls and was looking to build another. His attention turned to Sandusky, since the city had a lot going for it. For one, an interstate ran right through the area. Second, the city's population was exploding. Third, workers' salaries were well above the national average. Fourth, the city was located smack in the middle between Toledo and Cleveland. With the town picked out, they had to figure out where to build.

Several sites for the mall were considered. First, Cafaro looked into a few areas along Route 4. Then they looked at a couple of locations along Route 250. The one site that caught the company's attention was a stretch of farmland along Milan Road. The price of the land was cheapest of all the sites, and there was already an existing four-lane road in front of it. The location was perfect. Now Cafaro had to get the city on board. On

Build That Mall!

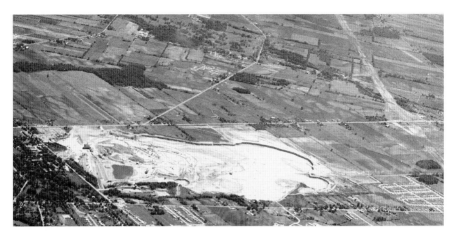

Construction of the Route 2 Highway. The area of farmland across the street from the Wagner Quarry is the future location of the Sandusky Mall, 1971. *Sandusky Library.*

December 28, 1971, Cafaro Co. announced a proposal of building a mall alongside Milan Road.

The company proposed a construction process that would occur in three phases. The first phase would see the construction of the 700,000-square-foot mall across eighty-five acres of land starting in the fall of 1972. This would give them seventy-five stores and 4,500 parking spots. (For reference: the nearby Woodville Mall had eighty-nine stores across 912,000 square feet, and the Elyria Midway Mall had fifty-four stores across 879,000 square feet). They would also build a shopping plaza on the northern side of the property.

The second phase would see the construction of twenty-four apartment buildings behind the mall. The third phase would add a suburb of residential homes consisting of 125 small plots of land.

The proposal was submitted that winter. Even though the city was on board with the idea, it raised a few issues that Cafaro needed to address before giving the green light. Since Wagner's Quarry would be right across the street, Cafaro needed to address how they would handle quarry dust and increased traffic to the area. They set to work on an updated proposal and scaled back their construction plans. The number of apartments was reduced from 24 to 13 and the number of residential homes from 125 to 97.

After Cafaro Co. submitted its new proposal, it was finally given the green light, with a construction date of spring 1973. Early estimates of this project were totaling around $10 million. Unfortunately, when 1973 rolled around, a new problem emerged. This time, it manifested in the form of sewage treatment. Erie County's sanitary engineers were called in to inspect

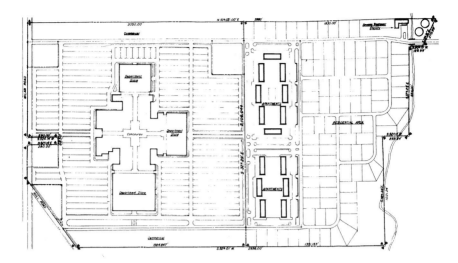

The original Sandusky Mall plans called for three tiers of construction, including apartment complexes behind the mall with a suburb behind it, 1972. *Sandusky Library.*

the land. It was revealed that there was no way that the existing sewage treatment plant and sewer system could accommodate all the new properties Cafaro intended to build. Everything would need to be upgraded in order to start construction. This costly endeavor came with an estimated price tag of an extra $10 million.

This was a major setback, delaying Cafaro's mall project almost a full year before a solution was reached. In 1974, the company revised its proposal a third time and decided to drop all of the previous plans of building apartments and residential homes. They hoped this revision would alleviate the sewage problems and avoid the need to upgrade the sewer system. The city approved the new proposal, and Cafaro was given new construction dates of August 1974 for the Mall Plaza and June 1975 for the Sandusky Mall.

Unfortunately, more studies conducted on the sewer system revealed that not upgrading the system would cause nearby residents years of problems and millions of dollars in damages. The city was left with no other choice but to file a lawsuit calling for Cafaro Co. to pay $465,000 to update the current sewer system in order to continue with its plans. In an ultimate act of generosity, Cafaro went above and beyond to appease city residents. Not only did the company build a brand-new sewer system, but it also gifted it to Erie County as a token of good faith to the community.

Kmart Plaza

Construction on the Mall Plaza began in August 1974. The anchor store brought in to be the first tenant was Kmart. The company that owned Kmart was no stranger to Sandusky. It first owned Kresge's downtown and closed that in 1964 to replace it with a smaller sister store, Jupiter, which remained until 1987. In the 1970s, the company was trying very hard to get a Kmart into Sandusky. The first area it tried securing was the property located at the Milan Road and Woodland Avenue area (which later became Skate World), but zoning issues plagued the proposal.

Once the Mall Plaza was approved in 1974, Kmart was signed on as the anchor store. This $2 million construction project lasted a few days short of a year. Once the project was underway, the demand for steel was at an all-time high. Cafaro turned to local steel fabricator Milan Steel for all of their needs. They became so overwhelmed by their steel demand that they added

Top: The Mall Plaza completed in mid-1976 housing Kmart and grocer Pick N Pay. *Sandusky Library.*

Bottom: Kmart's grand opening in June 1975. *Sandusky Library.*

a second shift just to keep up with the order of over five hundred thousand pounds of steel.

Finally, after eleven months of construction, Kmart held its grand opening on July 17, 1975. It opened 84,180 square feet of retail space housing fifty departments in all, including a large garden shop and an auto repair facility under one roof. This made Kmart a serious contender to the likes of Hills and Sears.

After Kmart was securely in place, local grocery chain Pick N Pay would be the next to open, in May 1976. This location became Pick N Pay's third Sandusky-area grocery store. Rounding out the plaza was Revco Drug Store, which opened in June 1976, and El Bee Shoe Outlet (owned by Elder Beerman), which opened in May 1976.

Mall Construction

After three years of construction setbacks, it was now time to get down to business and figure out which stores could be brought into the Sandusky Mall to be the anchor stores. The mall was big enough to support four anchors. Cafaro negotiated with J.C. Penney, Macy's, Sears, Montgomery Ward, LaSalle's and Higbee's, among others. Rumors swirled for months about which stores would make the final four. Then, toward the end of 1975, it was announced that J.C. Penney, Montgomery Ward, Carlisle Allen and Halle's would become the four anchor stores.

Construction on the J.C. Penney anchor store occurred first, beginning on June 14. It took six weeks to get all the support steel beams into place, eight months to complete exterior construction and two months to finish up the interior work. The construction workers employed on the job pretty much lived on-site. They ate at the Kmart Cafeteria for lunch and slept at Days Inn Motel across the street at night.

As the finishing touches were put on J.C. Penney, they closed their downtown location, transferred all of their employees to the new store and had enough room to hire seventy-five more. For those seventy-five new positions, more than eight hundred people applied! The hiring manager was a bit overwhelmed, to say the least. This was an early indication that the future of the mall looked bright.

Finally, on April 28, 1976, J.C. Penney opened its doors to the public by holding a huge ribbon-cutting ceremony. A crowd of people burst through the doors, all eager to catch a glimpse of the new anchor store that awaited

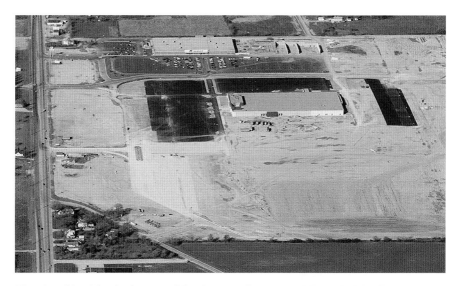

The plot of land for the future mall has been totally excavated. Both the Mall Plaza and J.C. Penney are partially constructed, November 15, 1975. *Sandusky Library*.

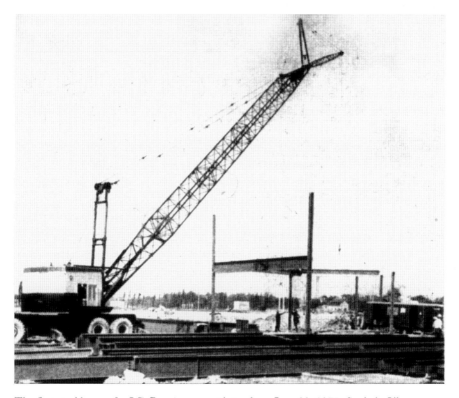

The first steel beams for J.C. Penney are put into place, June 20, 1975. *Sandusky Library*.

Above: Construction of the J.C. Penney building concludes; the parking lot is next to be worked on. *Eugene Muehling SR.*

Left: Construction on J.C. Penney's interior. *Cafaro Co.*

them. As J.C. Penney had gained over 110,000 square feet of retail space over its old location (30,000 square feet), the grand opening did not disappoint.

Construction on Montgomery Ward started on December 8 on the other side of the mall site. As the building went up, a huge empty lot sat between both buildings. It would take ten months for the second anchor store to be completed. Montgomery Ward held its grand opening on October 21, 1976. The store was a bit smaller than J.C. Penney, coming in at just under one hundred thousand square feet, but it had just as many departments.

Work on the mall's exterior began four months before Montgomery Ward was completed. Construction started on the north side, near J.C. Penney. Construction then slowly worked its way toward the Montgomery Ward side. The concrete walls steadily rose daily to create the outer wall and all of the smaller retail stores placed in between the first two anchors.

When it came to starting construction on the last two anchor stores, Halle's and Carlisle Allen, things hit a major snag. Both stores pulled out

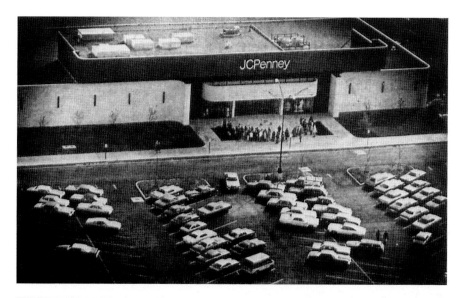

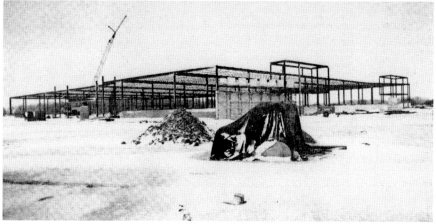

Top: Aerial view of J.C. Penney, taken on opening day, April 28, 1976. *Sandusky Library*.

Bottom: The steel framework of Montgomery Ward is completed, winter 1976. *Sandusky Library*.

at the last minute, causing a halt in construction. Since anchor stores had building approval, these locations couldn't be built without securing a tenant first. Cafaro scrambled to replace Halle's and quickly found a new tenant, Cohn's Boutique. Once they signed on, construction resumed.

The loss of Carlisle Allen, in contrast, was a bigger blow to the project, as it was harder to replace. This delay caused such a problem that the mall had to be built around the location until a replacement was found.

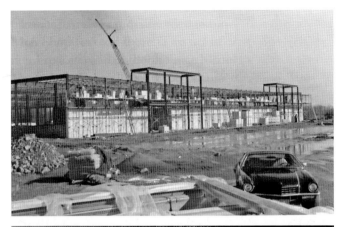

Top: Montgomery Ward interior work begins. *Cafaro Co.*

Bottom: Construction on Montgomery Ward interior, summer 1976. *Cafaro Co.*

Cafaro first struck a deal with Sears, which initially agreed but then backed out. It took over a year to find a replacement, but Cafaro finally signed May Company as the final anchor. Construction resumed in August 1977, finishing in 1979.

With all four anchors stores accounted for, Cafaro could now focus on filling the other seventy-five smaller spaces with tenants. As contracts started to be signed during the summer of '76, the mall was able to promise shoppers that at least twelve stores would be open and ready to go by the end of the year. The plan was to have an official grand opening celebration in March 1977, with a soft opening of the main enclosed part of the mall, called the concourse, to occur on November 17.

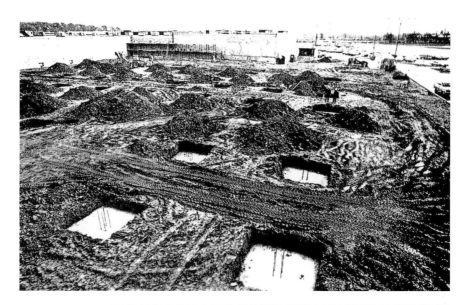

Above: Work on the final anchor store, May Co., begins, November 16, 1977. *Sandusky Library*.

Right: Putting the steel beams in place for May Co., February 15, 1978. *Elyria Public Library*

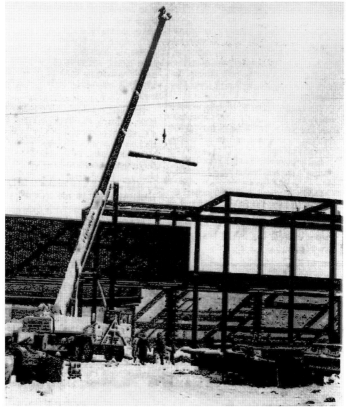

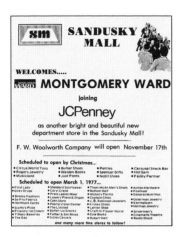

Sandusky Mall's public reveal ceremony flyer, October 20, 1976. *Sandusky Library.*

J.C. Penney, Montgomery Ward, Nobil Shoes, F.W. Woolworth, Circus World Toys, Spencer Gifts and Hallmark House of Cards were up and running in time for the soft opening. Only two of the mall's front entrances were opened to the large crowd of over ten thousand people in attendance to sneak a peek at the brand-new mall awaiting them.

Shoppers were treated to a shopping experience like no other. Entering the main hallway, a wide palette of retro colors greeted shoppers, mainly from the stained-glass murals covering the light fixtures high above. Various hues of blue and purple swirled together to create a giant, circular Tiffany-style pattern. Below that rested a huge water fountain, majestic in design. In the middle of the fountain stood a dark copper metal ring that spun around endlessly as a steady stream of water cascaded off of it and down into the pool below. If one looked into the water, one's gaze rested on hundreds of pennies and other coins lining the bottom. Each one represented a wish that someone had made while casting it in. The fountain was covered with a wall of dark brown marble. Large, heavy concrete seating areas were placed around it, with plants and shrubbery resting behind the fountain to give it a Zen-like feeling.

The mall had three of these beautiful water fountain areas. One sat in front of J.C. Penney, the second in front of Montgomery Ward (the fountain head was boomerang-shaped) and the third in the middle of the mall featuring a raised platform with water gushing out of waterfalls on either side of it.

Placed around the entire mall were vintage lampposts with huge glass globes, giving the mall an overall classy, 1800s feel. These lights provided an extra source of indoor lighting and were mostly found in rows of three or clusters of four.

As for the rest of the interior—well, it was far from complete. Since only seven of the more than seventy stores were open, the mall covered each unopened store with large pieces of plywood. The hope was that by the grand opening in five months, most of these stores would be open for business.

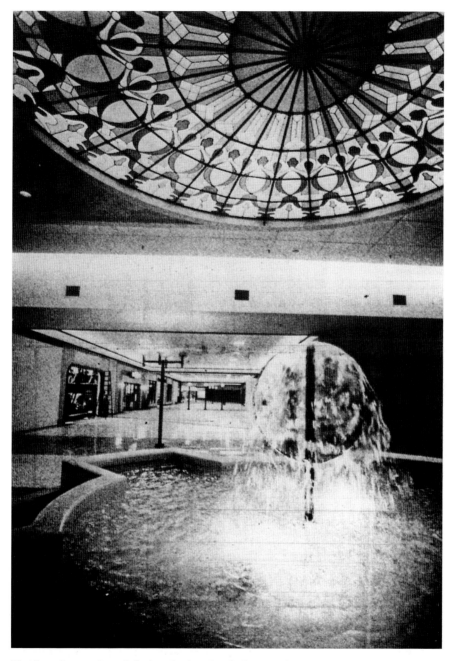

The first picture taken of the interior just days before opening to the public showing the elaborate J.C. Penney entrance water fountain and lighting fixture. In the background, Circus World and Woolworth are the only retail spaces with storefronts, November 15, 1976. *Sandusky Library*.

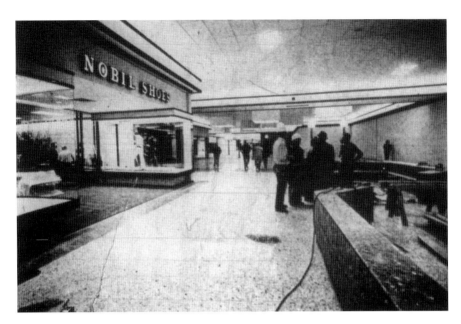

Toward the north end of the mall, Nobil Shoes is almost ready for the public grand opening. Petries is just behind it, with the seating area to the right still being completed. *Sandusky Library*.

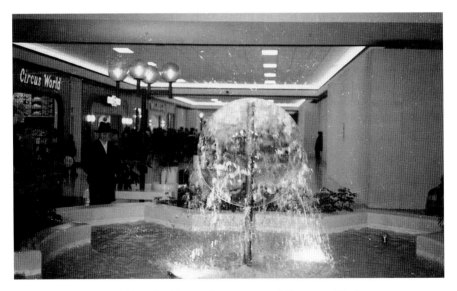

This photo was taken during the 1976 mall concourse public reveal. *Tim Bretz*.

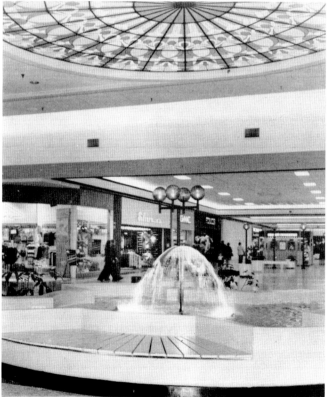

Above: Workers install all the necessary lightbulbs into the fancy lighting fixtures high above. *Sandusky Library*.

Left: Shoppers roam the southern hall. Storefronts visible from left to right are: Ragazza, Silverman's, GNC, Foxmoor, a boarded-up entrance to the future May Co. and Bottom Half. The Children's Portraits kiosk is seen on the right-hand side. *Jason McFarlin*.

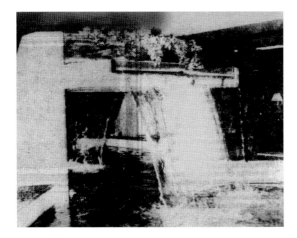

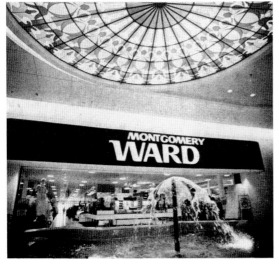

Top: The water fountain located in the middle of the concourse area. *Sandusky Library*.

Bottom: Montgomery Ward entrance featuring the horseshoe-shaped water fountain with the unique lighting fixture high above. *Sandusky Library*.

The mall's promotional director was thrilled with the success of the soft opening. "It was an excellent attendance for such a small number of stores. If this is any indication, we're going to have a very good mall."

In the days that followed, later in November, Musicland and Carousel Snack Bar opened. Waldenbooks, Astro Print, Fanny Farmer, Rogers Jewelers and Turquoise Shop opened in December, just in time for the holidays.

For retailers, the race was on to open by Christmas so that they could take advantage of holiday shopping season. During the first weekend of December alone, the mall received over four thousand visitors. Some of them regularly traveled from as far away as Oak Harbor.

A temporary mall kiosk, with Preis on the left and Hallmark's House of Cards on the right. *Sheila Franklin.*

In January, stores began opening at a record pace. Retail spaces were leased out and moved into before the ink on the lease agreement could dry. Before the grand opening in April, only two kiosks decided the mall wasn't for them and closed up shop: Astro Print (which took your picture and printed it onto a T-shirt) and the Turquoise Shop (the jewelry store refused to pay $1,000 a month for a ten-by-ten-foot booth).

With so much going on and so many tenants to take care of, the mall enlisted Fred Howell from Huron as mall manager to oversee operations. Leading up to the big day, the mall scheduled many events to drive foot traffic into the area. In January, it held a "Health-a-Rama" event, which brought in local health officials. February brought the first annual car show (the mall was built with giant doors that opened wide enough to allow cars and boats into the building). And in March, the mall held its first annual billiards tournament for kids.

The Sandusky Mall's official grand opening occurred on March 16, 1977. Only forty-five of the seventy-five tenants were able to open for the celebration. A ribbon cutting was held at 9:30 a.m.,

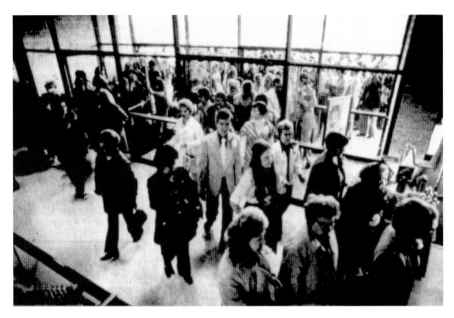

Crowd entering J.C. Penney on Opening Day, 1976. *Sandusky Library.*

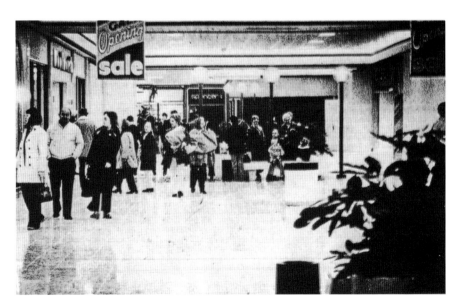

This photograph was taken during the 1976 mall concourse public reveal. *Sandusky Library.*

Businesses built around the Sandusky Mall:

1975 – Days Inn Motel
1976 – Arby's
1976 – McDonald's
1977 – Burger King
1977 – Big Boy
1977 – Pizza Hut
1977 – Sambo's Restaurant
1978 – Bonanza
1980 – The Market
1980 – Color Tile
1982 – Bob Evans
1984 – Country Kitchen
1985 – Firestone
1985 – Red Lobster
1985 – Chi-Chi's
1985 – Wendy's

followed by a whole day of amazing events and local celebrities. One of those celebrities happened to be Miss America 1977, Dorothy Benham, who did the honors of cutting the ribbon. Also on hand were Cleveland Cavalier stars Austin Carr and Jim Brewer and Cleveland Brown wide receiver Paul Warfield to sign autographs. The local Sandusky High School orchestra performed. Lottery raffles were held, with lucky winners receiving family vacations to Disney World.

The Sandusky Mall was an instant success. The grand opening sealed its stamp of approval with the city. Throughout the rest of 1977, the mall scheduled even more monthly events for the community. In May, a Girl Scouts sleepover was held. In June, a "25 for Hand-Jive 25" contest was held, consisting of twenty-five people placing their hands on a car in a last-man-standing contest to win the automobile. July offered a coin and stamp show and a "Mysterious Creature in Ice" display, in which a six-foot caveman-like creature was entombed in ice. (He's now currently on exhibit in Minnesota.) In July, Fourth of July fireworks were set up in the field behind the mall; it became a yearly tradition until 1986.

The Christmas season brought the biggest festivities of all. When Santa appeared at the mall for the first time that year, he was escorted by the

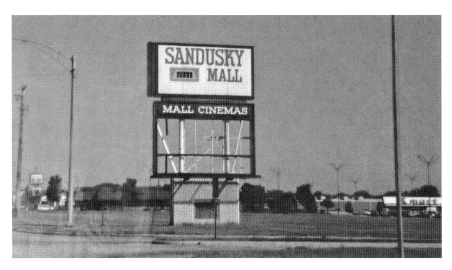

The exterior Sandusky Mall roadside sign. Work on the Mall Cinema display sign is halfway completed. *Lauren Dee*.

Above: The main concourse area is pretty empty, as seating areas are yet to be installed. In the background, large plywood boards line up and down the sides of the hallway of retail spaces awaiting their new tenants. *Sandusky Library*.

Opposite: The J.C. Penney entrance water fountain and light fixture with the newly opened Gray Drug in the background, March 16, 1977 *Elyria Library*.

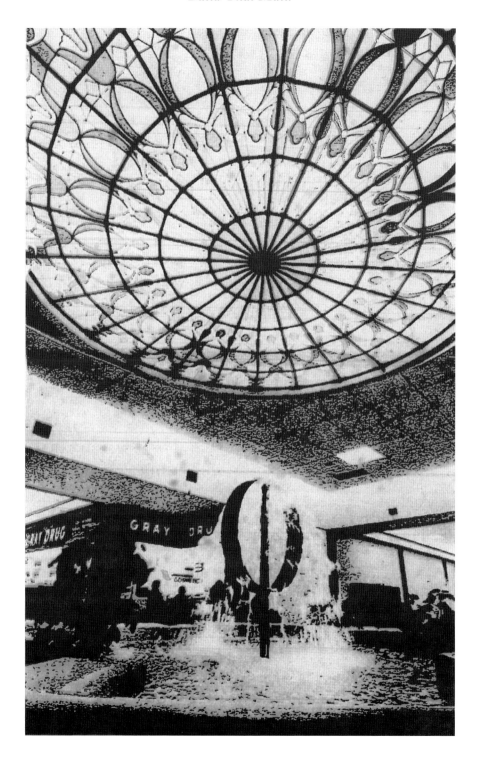

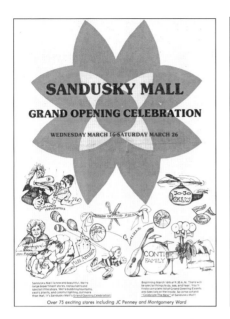

Left: The 1977 grand opening celebration pamphlet. *Sandusky Library*. *Right*: *Sandusky Library*.

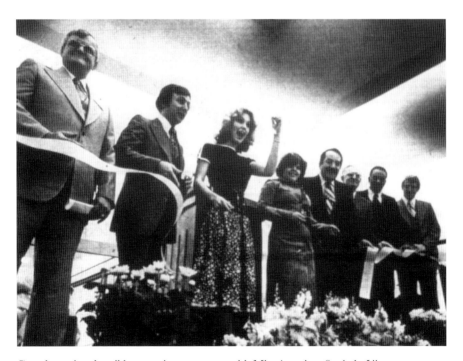

Grand opening day ribbon-cutting ceremony with Miss America. *Sandusky Library*.

From left: William Cafaro, Richard McHale (Montgomery Ward), and Miss America Dorothy Benham. *Sandusky Library*.

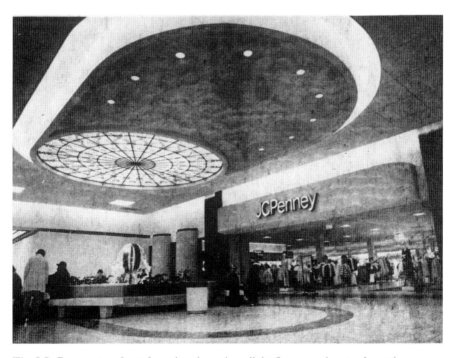

The J.C. Penney storefront featuring the unique light fixture and water fountain. *Sandusky Library*.

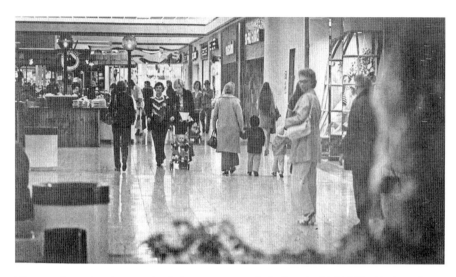

The grand opening day reveals all the new tenants, including the Lick Skillet kiosk on the left and storefronts on the right, including, Brooks Fashions, So-Fro Fabrics, Musicland, Butler's Shoes, Waldenbooks, Just*Pants and Petries. *Sandusky Library*.

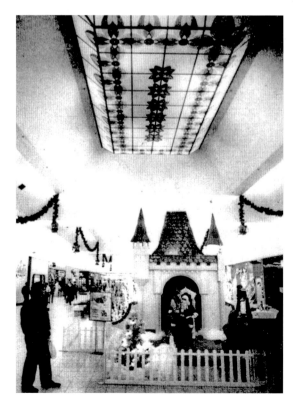

Santa sits in his castle area just below the main concourse lighting fixture. *Sandusky Library*.

Build That Mall!

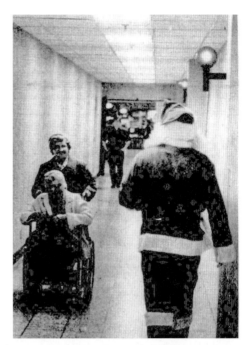

Right: Santa strolls down the entrance #5 hallway. *Sandusky Library*.

Below: More Christmas fun in the North Pole concourse. *Sarah Bartholomew*.

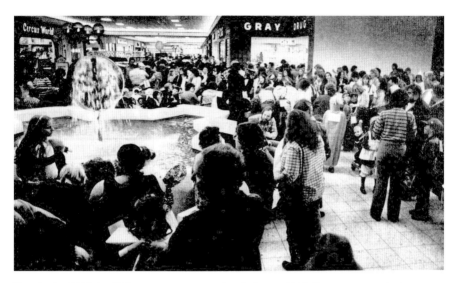

Hundreds of kids in Halloween costumes gather in front of J.C. Penney to partake in the trick-or-treat festivities. *Sandusky Library*.

Perkins High School Marching Band into his special North Pole area, complete with a huge castle display in the middle of the concourse. Even Pink Panther showed up alongside local Girl Scout troops for a special Christmas concert. A letter-mailing station was also set up, allowing kids to send letters to Santa.

Since the Christmas celebration was such a success, the mall tried celebrating Halloween the following year in the same "over-the-top" fashion. Festivities included a Halloween parade of kids from preschool to sixth grade, a costume party with multiple winners and an indoor trick-or-treating event in which stores handed out candy to kids. Since the *Evening News* had fear-mongered a story in which a kid found a razor blade in their candy that year, many overzealous neighborhoods were canceling trick-or-treating in their areas. The mall quickly remedied the problem by offering kids the chance to do so there. Hundreds of costumed kids showed up to collect candy.

In 1979, the mall upped the ante by inviting the local Jaycees chapter to set up a haunted house attraction in retail space #405. Older kids paid to go through the attraction as monsters jumped out and scared them. It was so successful that the event was continued for three more years.

Stores That Backed Out:

Carlisle Allen #500
Halle's #300
Friendly's Ice-Cream #285
Your Father's Moustache #370
Plaza-U Clothing #582
Cole National (Kiosk)
Third National Bank #350
Citizens Bank #350
Cedar Point
Red Lobster
Brown Derby

STORMS BEFORE THE CALM

Along with so many highlights in 1977, there were a few hurdles that challenged the mall that first year. The first happened on the evening of June 30. Disaster struck the city of Sandusky as a series of tornados ripped through Erie, Huron and Sandusky Counties. The Sandusky Mall sustained serious damage from a twister that touched down at 8:14 p.m. Around one thousand people were in the mall at the time. Without warning, the twister touched down in the vacant lot in front of the mall where the last anchor store was being built. At the time, the area was being prepped for construction with four large trailers parked out front. When the tornado touched down, it knocked over the trailers and smashed into the side of the mall.

When the tornado hit, the large sheet of plywood covering the future May Company entrance was pulled away from the wall and fell inward into the main concourse area. The heavy wall smashed onto the floor with a deafening crash. People scattered in every direction as rain and wind blew harshly inside. Panels were ripped away from the drop ceiling. Electrical fixtures were torn down and swung back and forth, dangling from wires still connected to the ceiling. Rainwater poured into the building and gushed into the nearby Foxmoor store. The huge concrete planters lining the hallway were toppled over and rolled down the concourse. It was complete chaos.

Employee Steve Miller, working at Foxmoor, recalls: "It sounded and looked like a train was pulling through that wall! I heard rumbling, people in the store got scared, and then there was a loud bang and the wall flew

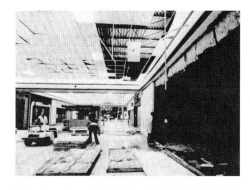

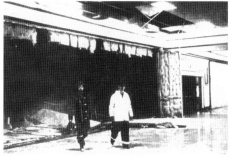

Top: May Co.'s fallen wall from the tornado damage, July 1, 1977. *Middle*: More tornado damage of the wall that fell in front of May Co. *Bottom*: Steve Miller and Chris Creque soaked from the storm. *Sandusky Library*.

open." The damage was so severe that the roof also began to give way from all of the leaking that occurred. Even a few heating units on the roof were ripped from their foundations and toppled over.

Outside the mall, things were even worse. All four construction trailers around the worksite had flipped onto their sides; one was completely flipped upside-down. Debris was scattered all over the parking lot area as well.

Mall manager Fred Howell ordered the entire mall closed six minutes after the wall blew in. After things calmed down, construction crews were called in to start repairing the damage the tornado had wrought. Crews worked tirelessly through the night and for the next few days. The repair bill came to a whopping $34,000!

Along with the tornado misfortunes, the mall would face a second round of destructive weather during one of the harshest blizzards to hit Ohio, in 1978. During the last week of January, hurricane-force winds of up to forty miles per hour blasted though the state. Things got so out of control that the governor declared a state of emergency. So much snow was being dumped onto the ground that stores like Kmart had to resort to shoveling snow off their roofs to keep the heavy loads from causing cave-ins. Salt trucks were useless, since the snow fell faster than it could be cleared away.

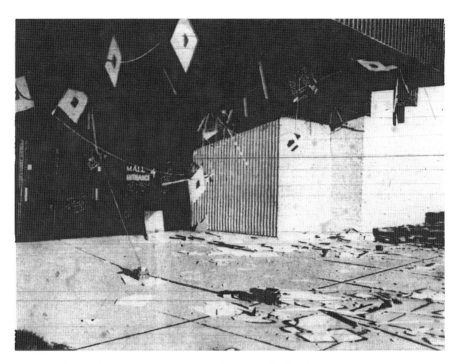

Tornado damage just outside mall entrance #4. *Elyria Public Library.*

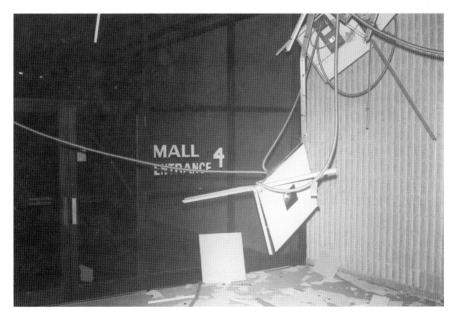

Broken ceiling fixtures dangling down. *Tim Bretz.*

Overturned construction trailers parked in the excavated May Co. lot. *Sandusky Library*.

When it came to the mall, the hurricane-force winds assaulted the building from every direction. That evening, after the mall had closed, the same plywood piece that had been blown out from the tornado touchdown was once again torn away from the wall. The heavy, thirty-foot section of wall, which had been double-braced this time, was tossed aside like confetti and smashed onto the floor a second time. The reinforced wall was no match for the '78 blizzard! All through the night, huge amounts of snow blew into the concourse area. Snow drifts began forming inside and grew by the hour, pelting nearby stores with tons of cold, icy snow.

When the mall opened the following morning, store workers were greeted with three-foot-high drifts accumulating in the main concourse. The interior had become a literal winter wonderland. Water in the nearby fountain had frozen solid, plants decorating the middle of the aisle were frozen stiff and everything nearby was covered in a thick layer of ice and snow. Nearby lighting fixtures were also damaged from the storm. Worst of all, the sprinkler system had been affected. Water pipes running overhead in the Bernard's Wigs store had frozen solid, causing them to burst. Everything was soaked with water. Stores like Flowerama had to throw their entire inventories away due to freezing temperatures killing everything. Other stores, like Father & Son Shoes, were drenched as water pooled inside from the melting snow.

The incident, which happened on a Thursday, caused the entire mall to shut down for the rest of the week. Crews managed to repair the exposed hole by Friday evening, but the mall's electricity had to remain off for four days until the damage was repaired. Only three stores were able to open on Sunday: J.C. Penney, Gray Drug and Montgomery Ward. Everyone else

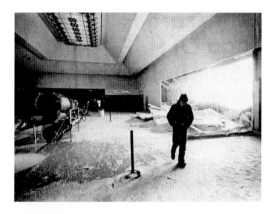

Top: The blizzard of 1978 knocked down the May Co. wall yet again. Snow blows into the concourse, December 27, 1978. *Sandusky Library*.

Bottom: Father & Son Shoes storefront gets hammered with ice and snow. *Sandusky Library*.

remained closed until Tuesday. The stores most affected were the ones selling perishable foods, like GNC. Spoiled food caused a huge loss in revenue during the shutdown. The repair bill this time came to around $15,000, less than half of what the tornado had caused.

With both disasters behind it, the mall could finally weather the storm into greener pastures. The rest of 1978 went off without a hitch, as a total of seventy-six stores were opened; only seven vacant spots remained to be filled. May Company was a year out from opening, and the mall finally installed an information booth in the middle of the concourse. The mall was able to make big profits there by selling lottery tickets and renting baby strollers to shoppers.

The Sandusky Mall continued to hold events for the community, including boat shows, deer farm attractions, antiques shows, gem and mineral shows and car shows. The circus even made a pit stop that year in the parking lot. Celebrities were brought in for autograph signings, including Gordon from *Sesame Street* and Hoolihan & Big Chuck (TV personalities on local WJW Cleveland channel 8). Even Mickey Mouse stopped by for his fiftieth birthday.

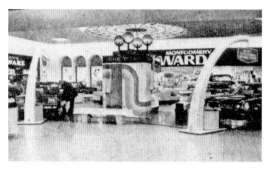

Top: The south end features Action Hardware (*left*), a retro photo booth (*center*) and Montgomery Ward (*background*). *Sandusky Library*.

Bottom: A car show taking place in front of Radio Shack. The photograph reveals the old wood-panel entrance into the mall. *Sandusky Library*.

Finally, in 1979, two years after the mall had officially opened, construction on May Company was completed on March 2. This gave the mall the final anchor store it was hoping for. Finally, all four anchors were in place. This feel-good moment was short-lived, however. Two weeks later, Cohn's announced that it was going out of business. Cafaro jumped into action and quickly found a replacement. Halle's stepped up to the plate to be the replacement fourth anchor, entering the mall in 1980.

ANNIVERSARY PARTY

When the Sandusky Mall held its first-anniversary party, the company decided to make it a star-studded event. It brought in former tennis star Bobby Riggs to be one of the celebration's highlights. It had been four years since Briggs had famously been defeated at the hands of female tennis player Billie Jean King. He went on to do many appearances around the country. Riggs faced off against a few local tennis pros in the area, including a few kids from Perkins High School.

Build That Mall!

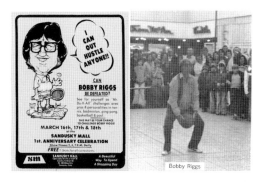

Bobby Riggs

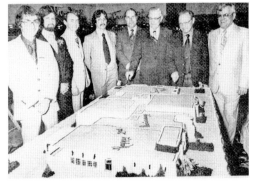

Top: Tennis legend Boggy Riggs shows up to compete against local players. *Perkins High School Alumni*.

Middle: Executives celebrate the mall's second anniversary with a cake in the shape of the Sandusky Mall in the middle of the concourse. *Sandusky Library*.

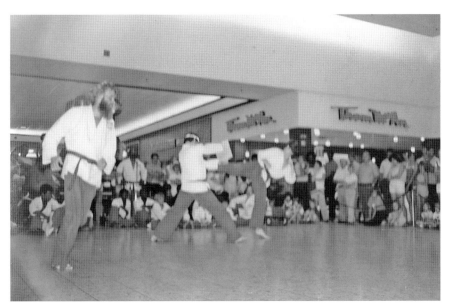

A martial arts event takes place in the concourse area. Stores in the background include Thom McAn, Naturalizer Shoes and the Bottom Half. *Herman Horn*.

The Plot Behind the Mall?
When Cafaro Co. originally came up with its first mall proposal in 1972, plans for behind the mall were squashed by sewage issues. Unfortunately, that wasn't the only time plans fell through.

1974 — New plans called for a shopping plaza to be built behind the mall. That never materialized.

1981 — A proposal was made to build family condominiums. That failed.

1983 — A proposal was made to build a convention center with a concert hall to hold 8,000 people with an attached dinner theater. That failed.

1995 — A proposal called for an apartment complex to be built for seniors. That also failed.

2006 — A luxury condo plan was proposed. Only 70 condos were pre-sold out of 1,500, scrapping the idea.

The mall's second anniversary, in 1979, was an even bigger spectacle. Events included square dancing, karate demonstrations, a hot rod car show, swimming pool giveaways and a cake-cutting celebration featuring a gigantic cake in the shape of the Sandusky Mall. It turned out to be one impressive frosted display piece.

Subsequent mall anniversaries were celebrated with weeklong sales events that most stores participated in. The mall celebrated its anniversary every March until its ninth year, in 1986.

3

STORES OF THE MALL

Photo credits for the images in this chapter can be found on page 143.

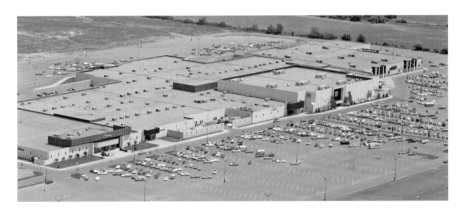

The Sandusky Mall's exterior, fully completed in 1979.

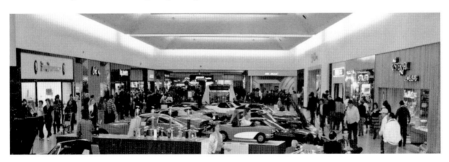

Stores in the concourse area in 1986. On the left are Fanny Farmer, Chic Wigs, Kay Jewelers, Hanover Shoes, Hallmark House of Cards and Endicott Johnson. On the right are Rogers Jewelers, The Gap, Mr. Music, Elder Beerman, Pearle Vision, The Limited and Osterman Jewelers.

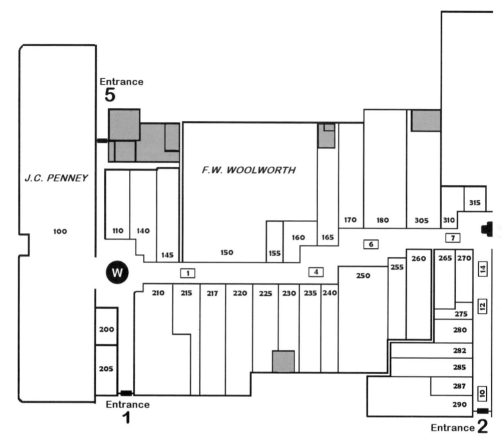

100: J.C. Penney
110: Rivet
 Payless Shoe Source
140: Diamond's Men Shop
 Chic
145: Circus World Toys
 Kay Bee Toys
150: F.W. Woolworth
155: Tiffany Bakeries
 Cuffles Fireplace Shop
 Claire's Boutique
160: Rogers Jewelry
 Suncoast Motion Picture Co.
165: The Gap
170: Standard Sportswear
 Fashion Bug
180: Caryl Crane
200: Buster Brown
 Slumber World
 Bedroom Plus
205: Magic Lady
210: Gray Drug
 Rite Aid

215: Brooks Fashions
217: World Bazaar
220: So-Fro Fabrics
225: Musicland
230: Butler's Shoes
235: Waldenbooks
240: Just*Pants
250: Petries
255: Spencer Gifts
260: Nobil Shoes
 Endicott Johnson
265: Hallmark House of Cards
270: Florsheim Shoes
 Hanover Shoes
272: Dipper Dan Ice-Cream
 Shop
 1 Hour Photo
275: Carousel Snack Bar
280: Scotto's Pizza
282: Athlete's Foot
285: Zondervan
287: Mothercare
290: York Steak House

305: Preis
 Gutman's
310: Mr. Music
315: Seven Seas
 Cedar Point Gifts
 Foot Locker
300: Cohn Department Store
 Halle's
 Elder Beerman
325: Pearle Vision
327: The Limited
330: Osterman Jewelers
340: Karmelkorn
345: Granny's Cookies
 David's Cookies
 Cheryl's Cookies
350: BancOhio
 First Buckeye Bank
370: Duke & Duchess
390: Murray's Law Office
400: Gold Mine
 BEST Products
405: Jaycee's Haunted House

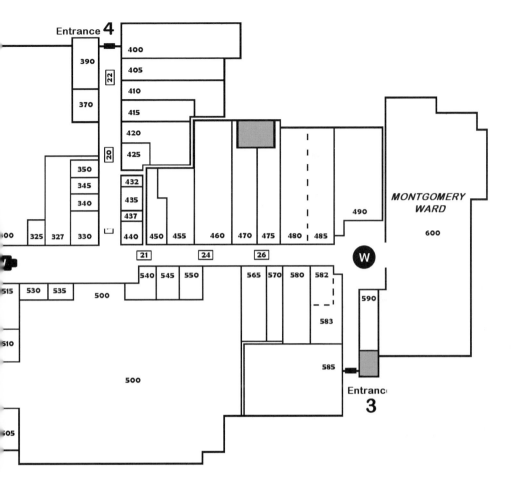

410: N/A (Never Occupied)
415: Petland
420: Holman's Jewelry
 Sheiban's Jewelry
 Christmas Gallery
425: Booklein
432: Hot Sam
435: Baskin Robbins
437: Batter-Up Snacks
 Hot Dog Corner
440: Father & Son Shoes
450: Susie's Casuals
455: Kinney Shoes
460: Lerner
470: Craft-N-Flower World
475: Coles Books
480: Robert Hall
 Hoty Sports
 Koenig Sports
485: Richmond Brothers
490: Action Hardware
 Angelo's
 Christmas Gallery

505: Hickory Farms
 Mr. Bulky's
507: Shoe Shanty
 The Universe & Other
 Toys
510: Captain Chips Potato Ship
 House of Vision
 E.B. Brown
512: Charlie Chan
 The Milky Way
515: JB Robinson
 Kay Jewelers
530: Bernard Wigs
 Chic Wigs
535: Fanny Farmer
500: Maymr. Co.
 Kauffman's
 Macy's
540: Thom McAn
 Leather Ltd.
545: Naturalizer Shoes
550: Bottom Half
 Little World

565: Foxmoor
 Dollar Tree
570: GNC
580: Silverman's
582: Ragazza
 Kara Tees
 Royal Optical
583: Gold Mine
585: Mall Cinema
590: Radio Shack
600: Montgomery Ward
 Sears

W: Water Fountain

100 BLOCK

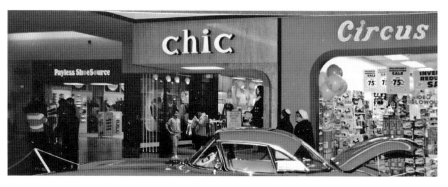

Stores in the 100 block, including Payless Shoes, Chic and Circus World, 1983.

100: J.C. PENNEY CO. (1976–PRESENT)

J.C. Penney restaurant menu, 1979.

J.C. Penney was founded in 1902 by James Penney, who opened his store in the small mining town of Kemmerer, Wyoming. By 1917, James had expanded his operation into 175 stores in twenty-two states. J.C. Penney entered the Sandusky area in 1929 with a store at 219 Columbus Avenue. Business was so good over the years that, in 1956, the company expanded by doubling the size of its retail space. The $650,000 project included updates to the building, with new features such as air-conditioning and escalators that took shoppers to a newly created second floor.

When the Sandusky Mall was announced, J.C. Penney was the first to sign on as an anchor store. The store left its downtown location of 30,000 square feet in favor of a new site, giving it over 140,000 feet. It was able to add many new departments, selling TVs, stereos, air conditioners, paint, hardware, typewriters, sporting goods, toys, luggage, books, cosmetics and LP records. It even added a candy shop, the Auto Care Center, a beauty salon and restaurant in the back righthand part of the store that could seat one hundred customers.

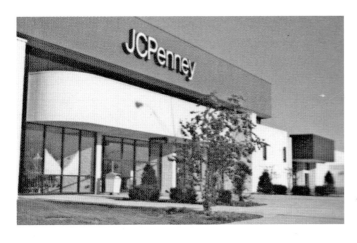

J.C. Penney exterior shot, 1979.

J.C. Penney was the first location to be built, and it opened at the mall on April 28, 1976. This was almost a full year before the mall officially opened. After its ribbon-cutting ceremony, a huge crowd of people burst through the doors to get a glimpse of the new store, which was more than four times as big as the downtown location. This was a sign of good things to come.

By 1979, J.C. Penney had 1,700 locations. The mall location was the first to bring microwaves to the area. In 1983, J.C. Penney remodeled all of its stores. During this restructuring, it shed the Auto Care Center, hardware department, lawn and garden section, appliance center and restaurant in favor of adding extra retail space for more home furnishings. Also in 1983, J.C. Penney found huge profits by offering the Atari VCS to kids, pushing the sale of Pac-Man and other games that holiday season.

Interestingly enough, J.C. Penney was the Sandusky Mall's first tenant and, as of this writing, is the last store remaining from the grand opening.

110: RIVET (1977–83); PAYLESS SHOE STORES (1984–2019)

Rivet arrived at the Sandusky Mall a couple of months late to the grand opening celebration, opening on June 9. Nestled beside J.C. Penney, its 2,300-square-foot location was considered prime real estate. Rivet, owned by May Company, focused on selling casual wear. The store name originated from the small metallic circles placed in Levi's jeans (rivets). By the end of 1977, Rivet had a store in every mall in northeast Ohio.

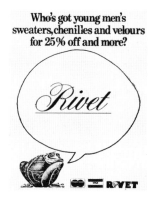

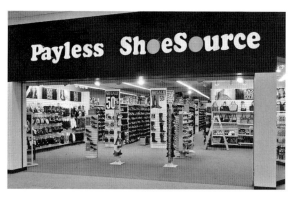

It specialized in selling Levi's fashions, dubbed "casual wear for both men and women." In the late 1970s, the store carried the latest bell-bottom jean fashions. It also sold shirts, jackets, outerwear, dress pants and even Jordache products. It catered to the working class by offering classy casual dress styles. Rivet especially flourished during the back-to-school season.

In 1981, the company began using a frog as its mascot, croaking the store name, "Rivet," instead of the traditional "ribbit" sound. Despite the clever marketing, by 1983, all of the Rivet stores were underperforming. May Company decided to close down all Rivet locations after the last week of December and reopen them as Payless Shoe Source stores (another company it owned) the following year. According to May Co., "We decided to take advantage of our shopping mall locations to expand the shoe stores."

Payless Shoe Source opened on February 1, 1984. At the time, there were 1,360 locations nationwide. The store carried over 9,500 pairs of shoes that were "affordably priced for the whole family."

In 2017, Payless faced huge financial problems and closed 673 stores nationwide. The Sandusky store was spared that time but, unfortunately, closed in 2019, when the company filed for a second Chapter 11 bankruptcy.

140: DIAMOND'S MEN SHOP (1977–80); CHIC (1982–86)

Diamond's Men Shop was a men's business suit store based in Cleveland, Ohio, and founded by Norman Diamond. Their first location was in the Southwyck Mall in Toledo. Diamond's opened up in Sandusky a month after the mall's grand opening and catered to the upscale businessman. It offered a large line of quality clothing and accessories, including suits,

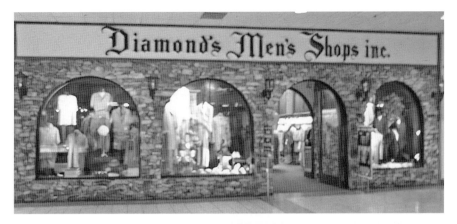

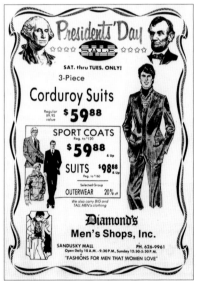

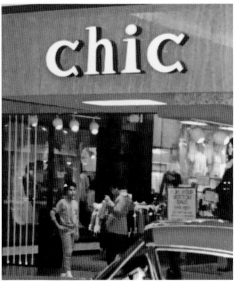

Top: Diamond Men's Shops storefront until 1980. *Bottom right*: The new 140 storefront changed to Chic in 1985.

sport coats and raincoats. The store measured 4,500 square feet, giving it enough room to add a hat and a shoe department as well.

In November 1979, Diamond's Men ran into financial issues, causing it to stop paying on its lease. The mall filed a court order to collect $29,000 in fees, which the store never paid. Cafaro then filed an eviction notice, and Diamond's refused to leave. When both parties went to court the following week, the case was oddly thrown out due to lack of prosecution. Things became even more intense when Cafaro leased the retail space to Manhattan

Clothing. As that company tried to move in, it quickly found that Diamond's Men Shop was still there. This act of squatting left Manhattan without the retail space it had paid for. Since it couldn't move in, it had no other choice but to sue the mall, for $150,000 in damages. It never was made public what happened next, but Diamond's was finally forced out. Manhattan Clothing never leased a different space at the mall. In a weird twist, however, Diamond's Men Shop did return to the mall in the 1990s, so amends seemed to have been made.

With Manhattan Clothing out of the picture, Chic was the next company to arrive, in early 1982. This women's clothing store specialized in jeans and jean fashions. It carried brands such as Levi's, Calvin Klein, Jordache and more.

Capers clothing store replaced Chic in 1988, followed by $9.99 Stockroom in 1992.

145: CIRCUS WORLD (1976–90); KAY BEE TOYS (1991–2004)

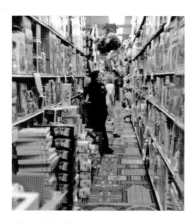

Circus World's third row of toys featuring kids' and girls' selections.

Every kid growing up in Sandusky has fond memories of shopping at the iconic toy store Circus World. It was the first toy store to open in Sandusky and was also one of the first handful of mall stores that opened by Christmas 1976. The company was founded in Taylor, Michigan, in 1964 and had thirty-eight stores across the Midwest at the time. Each store greeted kids with huge stuffed animals hanging from the ceiling. This gave the store a carnival feel when coupled with the bright orange-and-yellow color pallet found throughout the store. The plush animals hanging from the ceiling was mostly phased out in the 1980s, but the front of the store was always freshly stocked with smaller plush animals. The carpet adorning the floor was also very colorful and filled with various numbers and letters shown in fun and grandiose fonts.

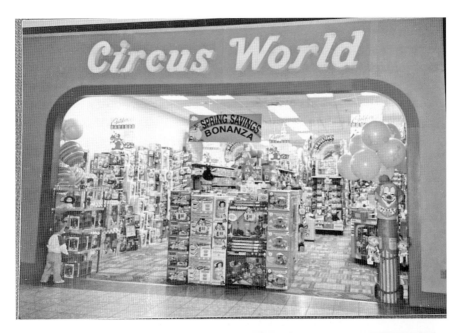

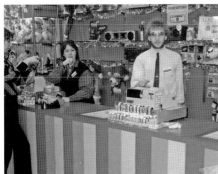

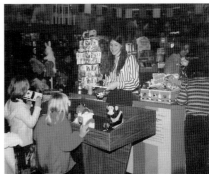

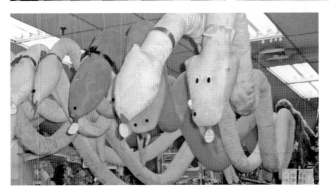

Middle, left: Circus World front counter area. *Middle, right*: Circus World's front area, containing the table where many toys making sounds were housed. *Left*: Many plush animals hang high above the registers in the front of the store.

Circus World utilized 3,500 square feet of retail space with three toy aisles stretching along the full length of the store. The first aisle was filled with toys catering to girls, the second aisle catered to boys and the last aisle held everything else, like puzzles, games and models.

Customers walking into the store were hit with an orchestra of sounds coming from a large wooden table with a clear plastic lip around it. Inside were numerous battery-operated musical toys—walking cats, barking dogs, monkeys with cymbals and clowns performing acrobatic tricks, among others. The sounds converged at once, creating a mythological siren-like call to any kid wandering past the store, luring them to drop everything and head inside.

The Christmas season of 1978 saw Star Wars toys explode off the shelves. The small toy store was caught in the crosshairs of it all and sold out within minutes. Three-inch figures and vehicles and playsets like Landspeeders, Tie Fighters, X-Wings, cardboard cantinas and Death Star stations all flew off the shelves. Circus World continued to see countless hot Christmas items pass through its doors each year. In 1980, it was He-Man, followed by Cabbage Patch Kids in 1983. Nintendo games for the NES exploded off the shelves starting in 1986. (I recall waiting for weeks for the store to finally get Super Mario Bros. 2 in stock. This was before the days when games were actually given exact release dates.) In 1989, Teenage Mutant Ninja Turtles and Batman toys were in demand. During the 1990s, those were replaced by Tickle Me Elmos, Teletubbies and Furby.

When the 1990s finally rolled in, the toy industry had become big business. Competitors were taking notice. Later that year, it was announced that Sandusky would be receiving two more dedicated toy stores: Children's Palace and Toys R Us.

Children's Palace was built on the mall property just outside the right-hand parking lot in front of Sears. The most impressive feature was that the building looked just like a castle. Two white towers with red caps standing fourteen feet high were placed on either side of the building to resemble a castle. The store opened on November 10, complete with a ribbon-cutting ceremony, shopping spree giveaways, face painting, coupons and balloons. Everything was freshly stocked, from Teenage Mutant Ninja Turtles action figures to Simpsons dolls. It even had a video game section that put Circus World's selection to shame.

In April 1991, Toys R Us also arrived on the scene in a 45,000-square-foot building in the new Park Place Plaza. The new toy store outclassed the competition in every way possible. The store was twice as big as Children's Palace and gave it a run for the money from day one.

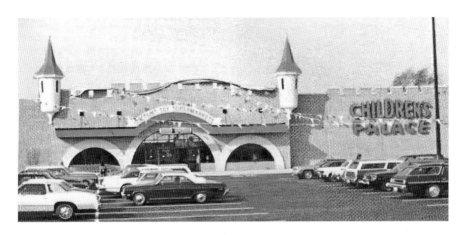

That summer, Children's Palace began running into major financial troubles. It could not keep up with the competition and quickly lost $192 million in 1990. With 150 stores in operation, Children's Palace decided after the 1991 holiday season that it would close all underperforming stores. With Toys R Us and Circus World both taking a chunk out of toy profits that year, the store closed on December 31, just over a year from opening.

Circus World Toys continued on, with Toys R Us hot on its heels, over the next decade. In 1990, Circus World was sold to the Melville Corporation, which rebranded all of its stores as Kay-Bee Toys in 1991. The store remained open for thirteen more years before filing for Chapter 11 bankruptcy in 2004.

150: F.W. WOOLWORTH (1977–93)

The first Woolworth opened in 1879 in Utica, New York, and was touted as one of the largest variety store chains in its heyday. In the 1950s, Woolworth began placing stores throughout the country in smaller downtown locations, including Sandusky. When the Sandusky Plaza opened in 1956, Woolworth opened its second area location. The company then moved its downtown operation to Perkins Plaza when that opened in 1966. A final move, to Sandusky Mall, was made in November 1976. All of the other Sandusky locations were then closed.

The company was very ambitious and always carried a wide variety of items within its many departments. With over twenty-six thousand square feet of retail space, it was able to expand its inventory by 80 percent from its plaza location. This gave the store larger shoe, housewares and clothing departments. It added departments for glassware, dinnerware, sporting

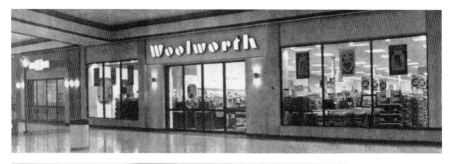

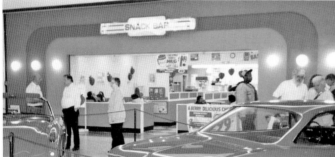

Top: Woolworth with Harvest House Jr. Café to the left, 1977.

Left: Woolworth Harvest House Jr. Cafe, 1980.

goods and toys to the mix. Woolworth even had enough room for a dedicated pet department and a bulk candy counter in the back.

Located to the left of the store's entrance was the Woolworth Café, with the letters *JR* resting high above the doorway entrance. The café was unofficially named the Harvest House Jr. Cafeteria. The little café was a traditional sandwich shop with a long tabletop railing checkout counter in the back. Customers had easy access for grabbing food from the window area and then sliding their tray down to the next station until reaching the register at the end. The menu consisted of typical diner food: sandwiches, turkey dinners, mashed potatoes, hot dogs, root beer and soft drinks.

The orange-and-yellow-striped wallpaper gave the café a year-round fall season look, reflected the restaurant's name. Retro can-like lighting fixtures with small pinholes in them hung from the ceiling. Colors of bright orange, yellow and gold adorned everything from the walls to the orange tabletops and bucket seating area in the front. There was even a fancy yellow/orange glass bottle windows on top of the low walls around the café.

Woolworth made the sad announcement on September 24, 1993, that the store was closing. It had lasted twenty-six years in Sandusky, but it was the '90s that did it in. With the increased competition to the area and a slowed economy, Woolworth just couldn't stay afloat. The store closed on January 31, 1994. The company closed all of its stores except for one, which still operates in Bakersfield, California, today.

155: TIFFANY'S BAKERIES (1977–79); CUFFLE'S FIREPLACE SHOP (1979–83); CLAIRE'S BOUTIQUE (1984–PRESENT)

Tiffany's Bakeries had you covered when it came to sweet baked goods. Based out of Toronto, Ontario, in 1969, Tiffany's served up a full range of bakery items such as cupcakes, breads, brownies, donuts, personalized cakes and more. They called themselves the "fast food bakery" and carried over thirty breads, including Italian, cinnamon and triticale. The store was named after the Tiffany lamps hung throughout the store to replicate the feeling of an old bread shop. Every employee also wore old-fashioned pinafore aprons, just like the old days. You could even watch the bakers cook your treats behind the counter after ordering. The chain of bakeries had 230 locations by 1978, and all orders were baked fresh daily.

Tiffany's even took part in the Revco Strawberry Festival in July 1978, held in the Mall Plaza parking lot. Tiffany's baked the "world's biggest strawberry shortcake" for the fun summer event. Despite its contributions, Tiffany's quietly closed in mid-1979; the company remained in business until 1982.

Cuffle's Fireplace Shop replaced Tiffany's Bakeries later that year. Based out of Niles, Ohio, this was the fourth location of the retail chain. Cuffle's was dedicated to all things for the home fireplace. The store delivered and installed equipment and made sure to fix every heating need for the home. It offered wood-burning stoves, heaters, furnaces, fireplace doors, fireplace accessories and more.

Claire's Boutique entered next, in 1984, and offered a wide variety of women's hair, nails and facial accessories.

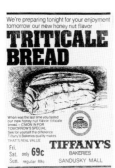
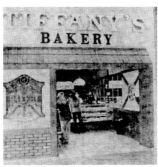

160: ROGERS JEWELERS (1976–90); SUNCOAST MOTION PICTURE COMPANY (1990–2006)

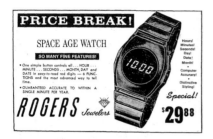

Rogers Jewelers was one of the first stores to open in the mall in 1976. It was also the first jewelry store in a long line of mall jewelers. Rogers began in 1920 and was based out of Akron, Ohio, with twenty stores in Ohio and West Virginia at the time. When it opened in the mall, it offered a new layout design that included glass-free showcases and sit-down viewing cases. It housed a gallery of diamond rings and jewelry, in addition to watches by Bulova and Caravelle.

Suncoast Motion Picture Company replaced Rogers Jewelers in 1990. It was founded in 1986 in Roseville, Minnesota. It specialized in selling new movies on all of the latest media formats, including VHS, LaserDisc and, later, DVD. Suncoast also carried novelty items such as movie posters, branded movie memorabilia, shirts, coats, action figures and even customizable Oscar statues that could be engraved with any name. When the store opened, it even carried video games for a short time.

Unfortunately, as the Internet grew and streaming services became more popular, sales of DVDs and movies plummeted, causing Suncoast to file Chapter 11 bankruptcy in 2006.

165: THE GAP (1977–2001)

When it came to wanting the latest and greatest fashions in jeans, The Gap had you covered. This San Francisco–based company, founded in 1969, had 210 stores nationwide by 1977. Levi's was its most important brand. From kid's size 0 to 42, The Gap carried all the latest fashions, including fuller cut men's jeans, bell-bottoms, coordinating tops for guys and girls and even casual clothes.

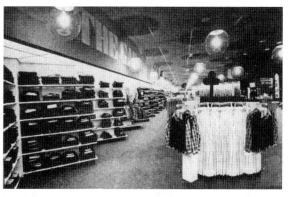

In July 2001, The Gap decided against renewing its lease. This wasn't because of poor sales, but because it hoped to find a bigger location to accommodate a GapKids store. This never materialized, and the vacant retail space was taken by Hallmark in 2001.

170: STANDARD SPORTSWEAR (1977–82); FASHION BUG (1982–93)

Standard Sportswear entered the mall in June 1977. The company was established in 1962 in Pittsburgh, Pennsylvania. Its specialty was men's and boys' casual and dress clothes. This included jeans, slacks, denim, corduroy pants, sportswear, jackets and coats. Even though the store carried all the famous brands of the day, including Levi, Haggar, Wright, Career Club, Sundowner and more, the store closed in March 1982.

Fashion Bug took over later in 1982 to cater to women of all ages and sizes. The store included women's plus-sized apparel, which few stores did at the time. It offered a wide range of apparel, from casual wear to dress wear.

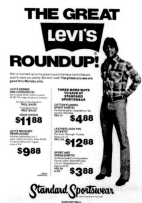

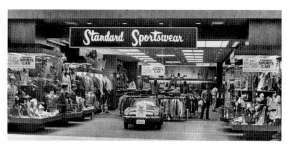

180: CARYL CRANE (1977–83)

If there ever was a local celebrity in a mall store, Caryl Crane was it. Named after the owner, Caryl Crane, the store had previously been a longtime Sandusky storefront staple located downtown at 229 Columbus Avenue (between LaSalle's and J.C. Penney.)

Caryl Crane (formally known as Fannie Shiff) opened her store in 1946 with her brother. When the Sandusky Mall was built, Crane felt the time was right to move out of downtown in favor of the new mall. The new store upgraded her retail space from 1,600 square feet to over 7,300. The store that once sold only dresses, suits, coats and lingerie could now sell sportswear, bridal clothes and jewelry. The biggest upgrade was the addition of a modern Estée Lauder perfume bar—a rare bonus that no one else had at the time.

The Caryl Crane storefront had a memorable, futuristic architecture that definitely stood out to anyone looking down the mall's hallway. Colorful and retro for the time, the storefront was made with a mix of Plexiglas and tambour wood. I still recall when, as a kid, I saw how the mannequins behind the front glass posed with colorful backgrounds behind them. The scene looked straight out of a 1970s *Price Is Right* studio set. Even the ceiling inside the store was unique, with huge baffles overhead and decorative lighting spread throughout.

It should be noted that Caryl Crane was no slouch in the fashion department, either, as she had become quite the trendsetter. She graced the covers of both *Harpers* and *Vogue*, appeared in Broadway musicals and sang at Carnegie Hall with the New York Philharmonic Orchestra for a public radio presentation.

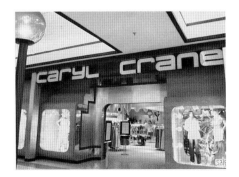

Above: Caryl Crane and her brother in front of their store.

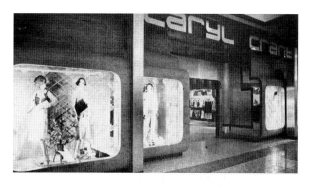

After five years in the mall, Caryl decided to retire and sold the store to new owners. She moved on to other ventures and opened up a children's theater downtown in 1986. Caryl passed away in 1999 at the age of ninety-one. She was remembered by local Firelands College, which named its youth theater after her.

As for the new owners, they kept the store open until the lease was up on January 1, 1986, and moved into a smaller location in Norwalk, Ohio.

The large retail space left behind was broken up into two smaller locations. A women's fashion store called Maurice's took four thousand square feet of space on the left, while Lane Bryant, a plus-size women's clothing shop, took the three thousand square feet of space on the right.

200 BLOCK

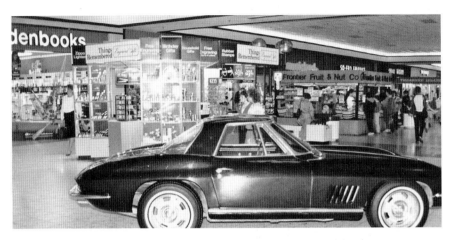

The 200 block of stores, including (*left to right*) Waldenbooks, Butler's Shoes, Musicland, So-Fro Fabrics, World Bazaar and Brooks Fashions in back. In front are kiosks Things Remembered, Fruit & Nut Co. and Treasure Island, 1986.

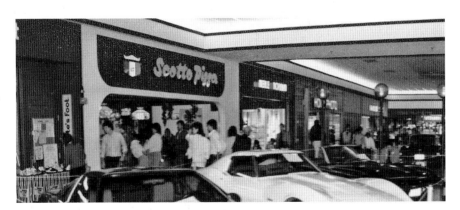

The 200 block of stores including (*left to right*) Athlete's Foot, Scotto's Pizza, Merle Norman, 1 Hour Photo and Hanover Shoes. Cedar Point Gifts is also seen on the right behind that, 1986.

200: BUSTER BROWN (1977–82);
SLUMBER WORLD (1982–87); BEDROOM PLUS (1989–90)

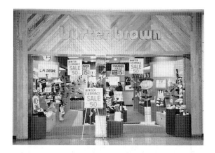

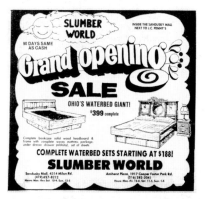

Slumber World interior showcase area.

One of the last shoe stores to enter the mall in 1977 was Buster Brown Shoes. The company, based in St. Louis, Missouri, was founded in 1878. This shoe-store chain began using the iconic comic book character Buster Brown as its mascot in 1904, and it went on to great fame in comic books, radio shows and more. The reason a kid character was used was because the company sold only children's shoes. The twelve-thousand-square-foot store offered sizes from infant to teenager. It also carried socks, polish and slippers. It was even one of the first stores to carry corrective shoes. By 1982, the over saturation of shoe stores in the mall took its toll on Buster Brown, and it closed by the end of the year. Even though the Sandusky location is long gone, the company is still thriving today.

Slumber World took over in 1982, dedicating a whole store to the breakout item of the decade: waterbeds! In 1982, waterbeds were all the rage, and Slumber World, founded in Ohio, became the product's largest retailer. It offered all kinds of mattresses, as well as everything from inflatable beds to bedroom furniture. It even sold waterbeds for baby cribs! Slumber World had seventeen stores at the time and carried bedroom accessories, massage recliners, custom lamps, bedding and more. As the fad began sinking toward the end of the decade, Slumber World defaulted on its lease and was sued for $49,000 before going bankrupt. Two years later, the retail space was replaced by another mattress seller, Bedroom Plus, which lasted only a little over a year before the company also went bust.

205: MAGIC LADY (1977–89)

Magic Lady was the first hair salon to open in the Sandusky Mall, on February 22, 1977. Based in Bel Air, California, the company was founded in the early 1970s with the slogan, "Beauty on a Budget." It pushed the concept of giving customers the hairstyle they wanted without the need for an appointment. Magic Lady offered a full-service salon with a variety of brand-name hair care products. Services included perms, hair tinting, facials and even wig styling.

Magic Lady closed down its chain and vacated the retail space in 1989. Oddly enough, a few months after the store's departure, one of the pipes of the sprinkler system burst in the ceiling above their store. The location had no floor drain, so water gushed out of the retail space and onto the concourse. Two

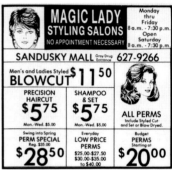

Top: Magic Lady interior, 1977.

inches of water began pooling there until it was noticed by the staff and the problem was fixed.

210: GRAY DRUG (1977–87); RITE AID (1988–97)

When Gray Drug came to the mall in March 1977, it was the company's fourth Sandusky location. The drugstore chain began in Cleveland, Ohio, in 1912. By 1977, it had 119 locations nationwide. The store carried over 2,500 different pharmaceuticals and offered a wide variety of other items customers could grab in a pinch, including toiletries, cleaning supplies, pet supplies, glassware and even snack items. For kids, the store even had toys and a few comic book racks by the doorway stocked with DC, Marvel and the hard-to-find Archie and Harvey comics.

Gray Drug was purchased by the paint company Sherman Williams in 1981 for $55 million. Six years later, in 1987, Sherwin Williams sold off its

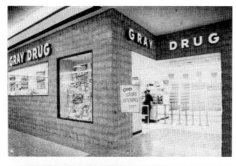
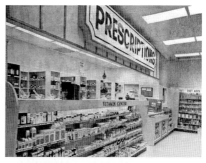
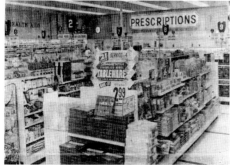
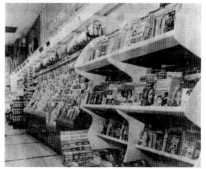

Top, right: Gray Drug counter area. *Bottom, left*: Rows of products at Gray Drug. *Bottom, right*: Gray Drug magazine and comic book selections.

investment to Rite Aid for $120 million, doubling its profit. All locations were converted into Rite Aid stores that June. Unfortunately, Rite Aid began closing underperforming stores in 1997 and closed the Sandusky Mall location.

215: BROOKS FASHIONS (1977–94)

Brooks Fashions was the new contemporary apparel store for petite-sized women from teens to adults. By focusing on the working girl and young housewife demographic, this New York–based chain from the 1940s made a big splash with 190 stores before heading to Sandusky. It offered a wide variety of modern-style clothing, including shirts, dresses, coasts, sportswear and accessories such as handbags and belts. The storefront was decorated with an elaborate display of windows and wood trim, giving it a modern greenhouse look. At the time, it was only the second Brooks Fashions store to be built with the greenhouse storefront.

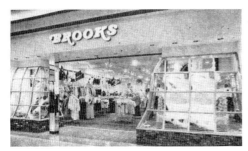

Right: Brooks Fashions interior.

Brooks was able to fulfill a lengthy tenure at Sandusky Mall of seventeen years before closing. When the store closed in 1989, it hardly came as a surprise, since the company had filed for bankruptcy in 1989, lost $21 million in 1992 and suffered another $80 million loss in sales during 1993. By 1994, the store franchise was no more.

217: WORLD BAZAAR (1977–90)

Before Pier 1 and World Market, there was World Bazaar. It entered the mall in December 1977 and was the only store selling novelty items handcrafted from around the world. The store was owned by Munford Inc. It had twenty-two stores in existence and had been based out of Georgia since 1965. World Bazaar occupied thirty-five hundred square feet in the mall and specialized in importing unusual, handcrafted home furnishings and gifts from several countries, including India, Russia, Korea, Japan, Hong Kong and Mexico. When I think back to the most iconic items the store carried, it had to be the

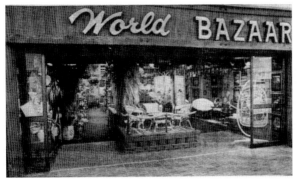

wicker furniture. Tons of wicker items were lined up and down the entire right-hand side of the store. Most of the inventory came from buying direct from crafters in remote islands, mountainous regions and seaport towns. The store also carried a wide variety of flowers, vases and baskets—tons and tons of wicker baskets! And who could forget the memorable wood-panel storefront? By 1980, World Bazaar had become the second-biggest importer of wicker in the country. Unfortunately, Munford Inc. ran into debt problems in the late '80s and filed for Chapter 11 bankruptcy on January 2, 1990. All locations were closed shortly thereafter.

220: So-Fro Fabrics (1977–91)

So-Fro Fabrics opened on February 18, 1979, one month before Sandusky Mall's grand opening. Based in Sun Valley, California, since 1946, this fabric store carried all the latest bolts of fabric you could ask for. Its inventory included intricate designs, patterns, sewing tools and more. The store had new fabrics debuting every two weeks and offered thousands of fabrics to choose from. If you couldn't find what you wanted, the store could special-order it.

In 1991, So-Fro Fabrics went through a restructuring process. It moved out of the Sandusky Mall and into the Mall Plaza to replace Revco. In 1998, the company was bought out by Jo-Ann Fabrics and moved its operation to the Perkins Plaza.

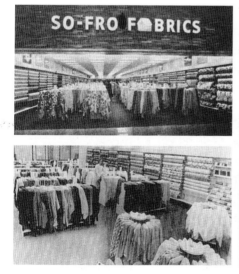
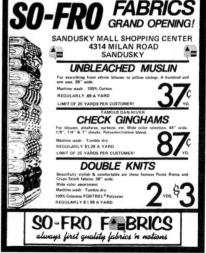

Left, bottom: So-Fro Fabrics interior.

225: MUSICLAND (1976–93)

Musicland was the memorable record shop in the mall that carried every album you could imagine. Established in Minneapolis, Minnesota, in 1955, it became the nation's largest chain of record stores by 1977 with almost four hundred locations. When it opened at the mall, the store boasted having thousands of album and tapes for sale within its three-thousand-square-foot retail space. It carried current best sellers, old albums and 45-rpm records. Musicland offered every genre of music imaginable, including children's, vocal, instrumental, religious, foreign, humor, dance, jazz and even classical. If it didn't have what you were looking for, it could special-order it. In addition to music, the store carried band T-shirts, posters, music memorabilia and sheet music. It even carried guitars, musical instruments, stereos and tape recorders when it first opened. Everything about Musicland's decor screamed 1970s. The colorful, patterned shag carpet and light fixtures defined the retro generation.

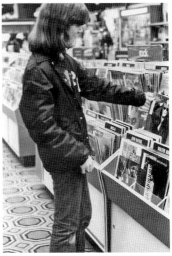

Bottom: A Perkins High School student browses through record albums at Musicland. Notice the iconic orange and red carpet.

The record store saw some memorable musical events throughout the 1980s. After John Lennon died in 1980, a line of people waited for the store to open the next morning in order to purchase all of his records. The store was sold out by noon. It then took Beatles albums, put them in the Johvn Lennon section, and those sold out as well.

One of the darkest chapters surrounding the Sandusky Mall occurred when Musicland assistant manager David Hartlaub, making his nightly bank deposit on February 27, 1988, was gunned down around 10:00 p.m. The murderers were three Hells Angels members who killed him in a case of mistaken identity. Each member was found guilty of aggravated murder and robbery. The news was so big that *America's Most Wanted* and Discovery Channel's *FBI Files* aired episodes of the case.

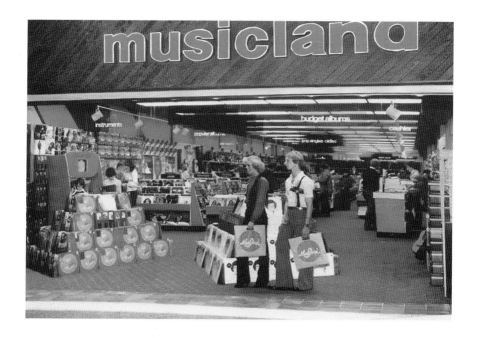

As the decades rolled on, Musicland changed with the times as music formats changed from audio cassette to compact disc. In 1993, all of Musicland's stores were rebranded under its parent company name, Sam Goody. Sam Goody was able to stay afloat until Internet audio file sharing began to impact sales. It closed in 2006.

230: BUTLER'S SHOES (1976–90)

Butler's Shoes was one of the five shoes stores in place when the mall had its grand opening in 1977. Butler Shoe Corp., established in Augusta, Georgia, in 1955, had well over 350 stores in operation by 1976. Instead of providing shoes for the whole family, they zeroed in on the women's market, allowing them to carry a meatier selection that outperformed the competition. They also carried shoes for children, handbags, accessories and hosiery. All of their shoes were imported from Italy, Spain and Greece shoemakers. As other shoe stores like Finish Line and Foot Locker became more popular, Butler's was forced to close all stores in 1990.

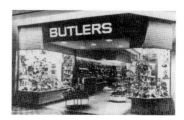

235: WALDENBOOKS (1976–2007)

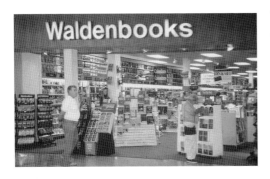

Waldenbooks was one of the first stores to arrive in the mall, on December 9, 1976. The company was founded in 1933 in Stamford, Connecticut. The name *Walden* came from the famous pond immortalized by Henry David Thoreau in his book. At the time, the company operated four hundred stores nationwide. The store featured hardcover, paperback and children's books in all genres, including fiction, nonfiction, Bibles, cooking and even gothic romance. The front half of the store was reserved for new releases, newspapers and magazines.

By 2000, Waldenbooks had outlasted all of the other mall bookstores. So, when *Harry Potter and the Goblet of Fire* was released on July 9 at midnight that year, it became one of the store's biggest events, with over forty families waiting at the door to pick up their reserved copy. It was such a hot item, you couldn't buy one without a pre-order. When the film was released in 2001, book sales only exploded from there. When the sixth book was released, over one hundred families were in line to help kick off a whole day of Harry Potter activities, including magic shows, arts and crafts, cosplay awards and more.

By 2007, huge changes were afoot at the mall. The company began closing Waldenbooks locations and replacing them with its larger chain, Borders. That April, Waldenbooks closed and Borders was built in the vacant retail space Rite-Aid left behind when it left in '97. To make the store fit, the entire face of the mall was reshaped; mall entrance #1 disappeared forever as that space was incorporated into the new floor plan for Borders. Six months later, on November 8, Borders was open for business. It was a huge upgrade from Waldenbooks, offering an additional twenty thousand square feet of retail space. It carried over 100,000 titles and ten thousand CDs and DVDs, and it also offered a digital center. Unfortunately, four years later, in 2011, Borders was hit with a huge bankruptcy issue and was forced to close 237 locations that year, including Sandusky's. Books-A-Million stepped in and filled the bookstore void a few months later.

240: JUST*PANTS (1976–90)

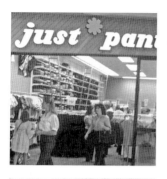

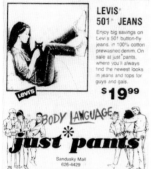

Don't let the name deceive you. Even though Just*Pants offered a huge variety of pants, it also offered tops and accessories for both men and women. It carried the latest fashions in jeans, jumpsuits and three-piece denim outfits in the most famous brand names, such as Levi's, Faded Glory, Sundowner and more. Every store had around five thousand pants in stock at all times. Just*Pants was founded in Chicago, Illinois, in 1969 by brothers Jerry and Dan Cohen. The franchise had over one hundred stores in existence by 1977. Every location that opened was an instant success because of the company's low prices on quality fashions.

In 1990, the company filed for Chapter 11 bankruptcy. Two years later, the corporate head, Charles Cohen, was taken to court in an advertisement-defrauding scam. He staged

Donna Lessick Gilbert showing off the interior of Just*Pants. The Gap is on the other side of the hallway, 1981.

fake advertising campaigns and then wrote up phony invoices to brands they worked with, like Levi's, to scam them out of $500,000. Cohen received a two-year prison sentence for his crime.

250: PETRIES (1976–95)

Petries was one of the first woman's apparel stores to enter the mall. Based out of Cleveland, Ohio, since 1927, the store was named after its founder, Milton Petrie. By 1976, he had amassed almost three hundred stores. Petries carried the latest fashions for women. The company had its own clothing line alongside other brand names, such as Stuarts, Marianne, David's and more. Its storefronts were famously adorned with mannequins on display wearing the latest fashions on sale.

The company began running into major financial problems in 1990, when sales dropped to a twenty-year low. It filed for bankruptcy in 1991, and things continued to decline until the Sandusky location closed in 1995. Victoria's Secret replaced it a year later.

255: SPENCER GIFTS (1976–2020)

Spencer Gift Shop was one of the more popular stores that capitalized on the 1970s teenage trends. The store branded itself as America's gallery for unusual gifts. Founded in 1963 in Cherry Hill, New Jersey, the company had 235 stores in existence by 1977. It quickly became the one-stop shop for everyone's hippie needs. Spencer Gifts carried lava lamps, black lights, black-light posters, barware, wall prints, bamboo curtains, adult games, puzzles, decorative lighting, fiber-optic lights and gag items. They even had a massive collection of branded T-shirts from famous rock bands of the day. In the back of the store, the store carried adult-themed novelty items that were more risqué. By the 1990s, Spencer Gifts quickly became the definitive place to shop for high-quality Halloween costumes. The retail chain did so well that it acquired the Spirit Halloween company and invested heavily on opening up temporary Spirit Halloween shops

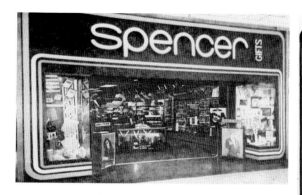

in vacant retail locations around the county throughout the holiday.

Spencer Gifts is one of the two original tenants still in business today at the Sandusky Mall, although that comes with a technicality, since it left in 1996 after the company was acquired by Universal Studios. The popular gift store made a comeback three years later and found a new home at retail spot #565. Spencer's remained at the mall until 2020, when the south wing of the mall was closed for remodeling.

260: NOBIL SHOES (1976–85); ENDICOTT JOHNSON (1985–92)

Nobil Shoes was one of the five shoe stores to grace the mall in 1977. When it opened, it was no stranger to Sandusky, since the company already had two locations in both the Sandusky Plaza and Perkins Plaza. This Akron-based company was founded in 1906 by a Russian immigrant and opened 216 locations by the 1970s. It offered shoes for every member of the family in every style imaginable. All of its latest fashions came from Greece, Brazil, Spain and Italy, among other countries. It even offered free repair services and shoe tinting. Nobil carried not only shoes but also handbags, accessories, socks and hosiery items.

In 1985, Nobil underwent a name change, to Endicott Johnson. Since Endicott had purchased Nobil Shoes in 1965, it decided to streamline

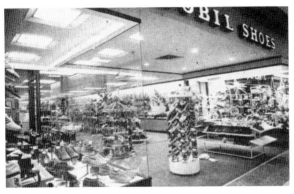
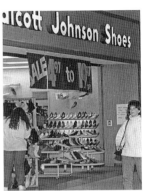

Left: Nobil Shoes storefront until 1985. *Right*: The 260 location switched to Endicott Johnson in 1985.

the brand by dropping the Nobil name. The Sandusky location remained open for seven more years before the company began feeling the heat of underperforming sales. As sales declined, the company was forced to shut down its shoe factories. In 1992, the company folded and all locations were closed.

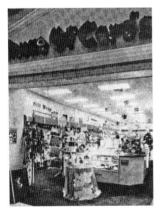

265: HOUSE OF CARDS: HALLMARK (1977–2016)

The House of Cards was a small chain of shops based out of West Virginia that carried greeting cards. It was a major retailer of Hallmark greeting cards, but it carried other items like party favors, stuffed animals, gift wrap, partyware, fancy stationery, balloons, key chains and more. The House of Cards storefront was unique for the time. It featured old-style lanterns adorning each side of the entrance. The name *House of Cards* was rebranded as *Hallmark* in the 1980s.

The best-selling item to hit the card store occurred in 1997, when Beanie Babies became

Bottom: Artist mockup of House of Cards.

an overnight success. Hallmark was one of the few places that carried the collectable, and it had customers lining up every week in hopes of scoring this hot item. In 2001, the store moved over to retail space #165 when The Gap vacated. Hallmark remained fifteen more years before leaving in 2016.

270: FLORSHEIM SHOES (1977–81); HANOVER SHOES (1982–86)

Middle: Florsheim Shoes storefront until 1981. *Bottom*: The 270 location became Hanover Shoes in 1982.

Florsheim Shoes catered to the businessman. The company was started in 1892 by Milton Florsheim in Chicago, and its stores carried a wide variety of higher-end dress shoes made from premium leathers. They carried these shoes in many hard-to-find sizes that other shoe stores didn't have. The small shoe store did very well at the mall, but in April 1981, its parent company decided to rebrand all Florsheim locations as its sister store, Hanover Shoes.

Hanover Shoes was one of the oldest and best-known shoe retailers in the country, with over 250 stores in existence by the 1980s. The company was also known for its four-thousand-acre farm and horse nursery in Hanover, Pennsylvania. The store stocked hundreds of the latest styles of shoes covering many genres. They were displayed in tall, revolving display windows, allowing customers to view them quickly and easily. From athletic shoes to dress shoes, the store carried many different lines. It even had its own brand of shoe alongside the Hush Puppies line it carried exclusively. By the mid-1980s, other shoe stores, like Journey's and Finish Line, became competitors, causing the company to shutter all underperforming stores, including the Sandusky location. Canary & Elephant novelty shop moved in next, selling smaller items like earrings, accessories and more.

272: DIPPER DAN'S ICE CREAM SHOP (1980–82); 1 HOUR PHOTO (1983–95)

Dipper Dan's Ice Cream Shop sold over forty flavors of ice cream and deli sandwiches to hungry shoppers. It was based out of Honeoye Falls, New York, beginning in 1921. The stores were modeled after the old-fashioned ice-cream parlors, and their specialty was serving ice cream in tasty waffle cones. They had all the staple ice-cream toppings, including hot fudge, sprinkles and nuts, among others. The store offered ice-cream cakes, pies and even hot and cold sandwiches, one of which was called the "Dipper Danwich." Unfortunately, Dipper Dan's didn't last long against stiff competition like Baskin Robbins. It went out of business by 1982.

Next at that location was 1 Hour Photo. The former ice-cream shop was remodeled into a full-service photo lab. At the time, the company had fifteen locations in operation. Since handheld cameras were becoming more commonplace, the demand for fast picture processing was skyrocketing—especially since other photo labs needed a few days to process pictures. Although digital photography is taken for granted today, back then, developing film in an hour was revolutionary. By paying an extra premium, you could go shopping and come back in time to pick up your pictures. The store offered prints in a variety of formats, from small photos to poster-sized pictures.

275: CAROUSEL SNACK BAR (1976–85)

The Sandusky Mall didn't have a traditional food court, but it did offer six snack locations by the end of 1976, with Carousel Snack Bar being the first. Based in Minneapolis, Minnesota, the company, which began in 1960, ballooned to two hundred stores by 1978. On the menu were

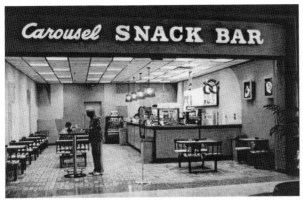

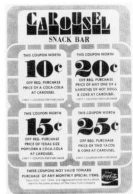

eight different kinds of hot dogs. These ranged from hot dogs, chili dogs and cheese dogs to kraut dogs, chili cheese dogs, Reuben dogs and more. You could also order pizza, barbecue beef, tacos, pretzels, French fries, popcorn, cotton candy, chocolate milk and soft drinks. The lavish walls of the snack bar featured bright, vivid colors of oranges, yellows and gold. The colors even carried over onto the countertops and work areas. The front of the stand was decked out with a cafeteria-style rail bar that you could slide your tray across. The snack stand lasted almost a decade before being replaced by Merle Norman, a cosmetic retail store based out of Los Angeles, California.

280: Scotto's Pizza (1977–2002)

The Scotto's Pizza franchise, based out of Brooklyn, New York, was begun in 1970 by Geraldo Scotto. This pizza place is considered an iconic staple of the Sandusky Mall for any kid growing up in the area. But it wasn't always an icon. Scotto's surprisingly didn't fair too well in the beginning. In an attempt

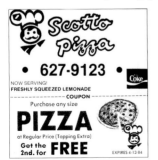

to drum up more business in 1980, it resorted to offering a breakfast menu in the mornings from 9:00 a.m. to noon.

Unfortunately, this odd idea didn't fix the problem. A change of ownership occurred in 1981, and Mario Buontempo stepped in and turned things around in a big way. Scotto's pizza would go on to thrive for an amazing twenty-five years as it became the go-to pizza place in

Left: Scotto Pizza storefront. *Right*: Mario Buontempo sitting in Mario Di Napoli's, 2002.

the mall. It also helped the community by sponsoring junior sports teams at local schools throughout the 1990s. One of the standout features of the storefront was the Italian insignia adorning the left-hand side of the logo. This was a feature exclusive to the Sandusky location.

In 2002, Buontempo broke free from the Scotto's Pizza franchise and rebranded the restaurant Mario's Pizzeria. This was a temporary change, until Buontempo closed his location for a major renovation and reopened a few weeks later as Mario Di Napoli's Eatery. This new establishment was three times larger than Scotto's Pizza, having gobbled up retail space #285. The indoor scenery came complete with stone statues, Vespas and faux windows to replicate the feel of eating in an actual Italian restaurant. His newer and bigger menu consisted of soups, salads, seafood, a pasta station, sandwiches, stromboli and deserts. It even had an authentic wood-fired stove to cook pizzas in the traditional way for pizza lovers. As Mario explained, "Sandusky needs some Italian specialty items. Everybody has the same menu. There is nothing else like this in the area."

Despite all these expensive upgrades, it seemed that people preferred Scotto's over the new eatery, and Mario Di Napoli's closed in 2006 after only four years of operation. It seemed that Scotto's Pizza was the secret recipe for success; after that, Sbarro's opened in August 2008, followed by Luca Pizza di Roma in 2012. Both lasted less than four years before having to go out of business.

282: ATHLETE'S FOOT (1979–93)

Cafaro had a hard time finding a business to lease out the large #285 retail space, so they broke it up into two smaller spaces, creating #282. Athlete's Foot found the square footage of the new location to be (pardon the pun) the perfect fit. Even though the mall already had ten shoe stores, Athlete's Foot was the only store catering to all things sports. The store was founded in 1971 by David Lando in Pittsburgh, Pennsylvania. By 1979, Lando had over 250 stores carrying shoes for football, track, baseball, jogging, tennis and even bowling! The Sandusky location had the phone number 626-FOOT. How cool is that?

In 1992, the store ran into a tough spot when its lease came up $26,000 short. The mall promptly filed a suit. Unfortunately, the lawsuit was misfiled, causing a fleet of sheriff's deputies to enter the store and begin seizing company assets. Athlete's Foot employees were completely shocked and quickly got the company's lawyers involved to help straighten out the misunderstanding. Everything returned to normal until one year later. Athlete's Foot again fell delinquent on its lease, by $4,000. This time, the company decided to close the underperforming store for good. VIP Sports replaced Athlete's Foot in 1994.

Athlete's Foot interior shots.

285: ZONDERVAN (1981–88)

Zondervan, a popular self-publisher of Christian books, found its way into the Sandusky Mall in 1981. Zondervan Family Bookstore catered to the religious crowd, offering numerous Bibles, statues, jewelry, religious music records and a large line of children's books. Zondervan was founded in 1931

in Grand Rapids, Michigan, and the Sandusky location was the company's sixty-first store.

Their book selection in the Christian market was second to none. In fact, during the 1970s, Zondervan was touted as the world's largest publisher of religious books. They printed not only Bibles, but also cookbooks, dictionaries, encyclopedias and how-to and fix-it books. Their catalog offered many items for the home, Catholic schools and even churches, including larger items like pews, pulpits and altars, as well as robes and more. They even began carrying Precious Moments figurines when the popularity of those exploded in 1985. The store had a decent run, being at the mall for seven years. That is interesting in itself, since seven serves as an important biblical number. After Zondervan left, the space was filled two years later by Russell's Tuxedo.

287: MOTHERCARE (1977–92)

Mothercare was the only store in the Sandusky Mall originally founded in the United Kingdom. This British company was created in 1963 with only twenty-seven stores in operation in the United States at the time of the mall's opening. It specialized in clothes specially fitted for pregnant women and for children up to age four. The store offered a wide variety of clothes covering all the styles a mom could ask for. It carried nursing and feeding tops, travel accessories, lingerie for expecting mothers and even baby toys.

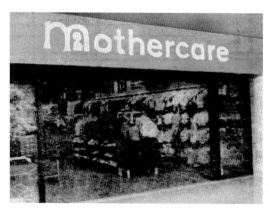
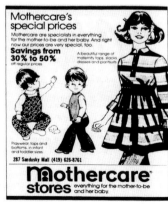

290: YORK STEAK HOUSE (1977–90)

York Steak House hailed from Columbus, Ohio, with sixty-five restaurants at the time. The company was founded in 1970 and came armed with a full menu of steaks, from sirloin to T-bone. It also offered a full kids menu, complete with hamburgers and roasted chicken. The decor at the time resembled an Olde English townhouse setting, made complete by having employees' outfits match the period. The twist on this place was that everything was ordered à la cart.

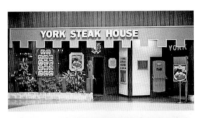

Menu items were plastered along the wall on your way in. Patrons picked their food, paid their items and then sat down inside the restaurant to eat. Tipping was not allowed, as York was a cafeteria-based business. In 1983, one of the most popular promotional ties-ins was with the toy brand Strawberry Shortcake. When children ordered a kids meal, they receive one of thirty-six figures to collect.

In April 1985, York Steakhouse underwent a drastic restructuring. The company changed the menu to include more items besides steak, including chicken dishes, salads, sandwiches and more. In addition, the name was changed to York Choices. The interior was revamped to reflect more of a medieval tavern setting, complete with dark lighting, wood furniture and iron chandeliers. Unfortunately, York Steak House sales declined after that, and the company sold off most of its restaurants to USA Café's Inc. in 1989. They then closed down all underperforming locations in 1990, including Sandusky's. Ponderosa replaced York Choices in 1990, followed by Ruby Tuesdays in 1995.

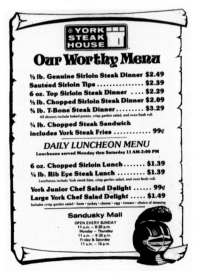

Middle: York Steakhouse's menu board area, where one ordered food before being seated.

300 BLOCK

The 300 block of stores during the annual fashion show, including (*left to right*) Cedar Point Gifts, Halle's, Pearle Vision, The Limited and Osterman Jewelers, 1980.

The 300 block of stores down the east hallway, including (*left to right*) Karmelkorn, Cheryl's Cookies, First Buckeye Bank, Elder Beerman, Duke & Duchess, mall entrance #4 and BEST Products, 1986.

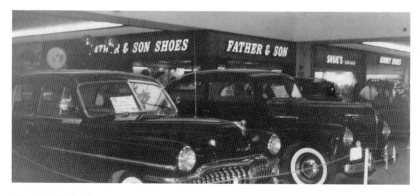

The 400 block of stores, including (*left to right*) Batter-Up Snacks, Father & Son Shoes, Susie's Casuals and Kinney Shoes, 1980.

305: Preis (1977–81); Gutman's (1982–85)

Preis was a Norwalk-based company with nine locations in Ohio and Michigan by 1977. Before coming into the mall, Preis was located in the Perkins Plaza. Its specialty was offering a full line of women's clothes. After only three years of operation, Preis ran into major financial troubles in June 1981 and stopped paying on its lease. Cafaro filed suit in an attempt to recover $13,000 in back payments. To settle its debt, Preis turned to a company called Gutman's to buy it out. Gutman's just happened to be a close business partner based in Buffalo, New York. After some quick negotiations, Gutman's agreed and acquired Preis that November.

Following the acquisition, the store was renamed Gutman's. Everything in the store remained the same, with the exception that Gutman's own fashion line was added to each department. Gutman's lasted three years before it, too, fell into financial hardships. It filed Chapter 11 bankruptcy on August 21, 1985, and closed the store without holding any clearance sales. The women's fashion store Deb replaced Gutman's later that year.

310: Mr. Music (1977–89)

Mr. Music carried a wide selection of Lowery organs and pianos made by

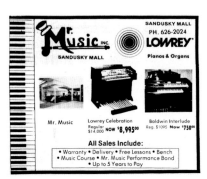

Story and Clark ranging from $1,000 to $11,000. The store also sold used organs, keyboards and budget pianos starting at $50, along with free group lessons. At the time, it was considered the largest home organ store, with three other locations located in Toledo, Mansfield and Ashland, Ohio. Mr. Music was also one of the few major manufacturers in the United States to

produce its own brand of instruments. The 1,700-square-foot store also delivered items to the home. Mr. Music lasted more than twelve years at the mall. In 1989, the company decided to close its Sandusky location in favor of a newer one in Toledo at the Woodville Mall.

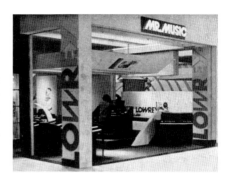

315: SEVEN SEAS (1977–78); CEDAR POINT GIFTS (1978–86); FOOT LOCKER (1986–2008)

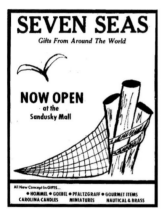

The Seven Seas was a small gift-shop business founded in 1966 that originally came from the Perkins Plaza. When the mall was built, it moved in, in February 1977. At the time, the chain of small gift shops had nine locations. They carried souvenirs, candles, party supplies, Hallmark greeting cards and even the collectable Hummel figurines popular in the 1970s.

In February 1978, Cedar Point Inc. bought out the Seven Seas retail chain. Since Seven Seas was owned by the Cedar Point chairman, George A. Roose, it only made sense. The amusement park was looking to expand into the souvenir market. This would extend its reach into mall storefronts. As Cedar Point president Robert Munger explained, "Gift stores produce year round revenues. We view this purchase as the initial step in a program of expansion." This was an especially profitable move, as Cedar Point's new Gemini roller coaster debuted in 1978. The store began carrying a wide variety of products featuring the Gemini logo, and they sold very well. The store even went as far as to have a model of the Gemini on display that year featuring the logo, "Highest! Fastest! Steepest! Roller Coast in the World."

When the name officially changed to Cedar Point Gifts in November '78, the store held a huge celebration, complete with giveaways of gift certificates, Cedar Point tickets, branded Frisbees, balloons and plenty of fruit punch, cookies and saltwater taffy for shoppers. After eight years, however, Cedar Point decided to nix the idea of retail stores and closed all of its locations. Foot Locker would replace the small souvenir store on March 15, 1986.

300: Cohn's Department Store (1977–79); Halle's (1980–82); Elder Beerman (1983–2018)

When the mall announced its anchor stores in 1976, Halle's was supposed to fill location #300. Unfortunately, that commitment fell through, and Cafaro Co. had to find a replacement. Cohn's Boutique in Perkins Plaza stepped up to fill the vacancy. The store, already a longtime staple in Sandusky, was first opened by Louis Cohn in 1876 in the downtown area at 132 Columbus Avenue. The store moved into the Perkins Plaza in 1965 and finally into the mall in 1977 to serve as the fourth anchor store.

Cohn's had always focused on selling men's clothes, but when it moved into the mall, it had thirty-eight thousand square feet to play with. It was able to add women's and children's clothing departments. Cohn's also worked with other retailers, like Manhattan Company, allowing them to run their own sections in their store. Cohn's also allowed Revlon to run a salon and Bertsch Jewelers to operate a jewelry department. In March 1979, Cohn's began facing serious financial troubles and defaulted on its lease of $88,000. The company had no choice but to close its stores. "Closed for inventory" signs mysteriously appeared in front of Cohn's a couple of days before the announcement that it was closing.

When Cohn's vacated, Cafaro turned to Halle's once more to see if it wanted to return as an anchor. This time, Halle's followed through and replaced Cohn's. Based in Cleveland, this retail chain operated seven stores,

Halle's ran this ad one frame at a time in the local newspaper to announce its grand opening at the mall.

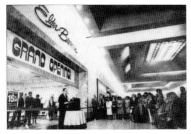

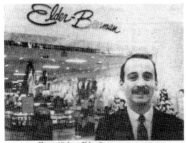

Shawn Hickey, Elder-Beerman manager.

Top: Halle's store signage from 1980–82. *Middle:* Elder Beerman grand opening ceremony.

with the Sandusky location being its eighth. Halle's was considered the leading department store in Cleveland at the time and sold the same type of merchandise as Cohn's. Halle's took out daily newspaper advertisements showing a baby chick being hatched in order to entice readers to attend the grand opening. The store offered a full line of fashion apparel in the latest styles.

Unfortunately, only a year and a half into its mall tenure, Halle's, too, ran into financial hardships. In January 1982, Halle's announced that it was selling off the company. The new owners planned on shutting down all of its stores. Cafaro was not happy with this surprise revelation and filed a $15 million lawsuit against the new owners of the Halle's store. Cafaro felt that the closure was being done in order to defraud Halle's stockholders, loot the company's assets and weasel out of the lease agreements.

It would take Cafaro Co. more than a year to line up Elder Beerman as the next anchor-store tenant. Even though this Dayton, Ohio retail chain was one hundred years old at the time, the Sandusky location would be just its twenty-first store. After many months of negotiations, Elder Beerman opened on March 1, 1983. The company spent $400,000 to fully remodel the space to fit its needs, adding women's, men's and children's clothing sections alongside twenty other departments, including cosmetics, jewelry, dresses, sportswear and shoes. In 1999, Elder Beerman went through a huge remodel and expanded into the empty BEST Products location. This increased the store's selling space from 38,700 to 94,000 square feet. The entire remodel process took five months. Elder Beerman enjoyed a very successful run throughout the new millennium, until 2018, when the company filed for Chapter 11 bankruptcy on April 17.

325: PEARLE VISION (1977–87)

Pearle Vision became the first eyeglass center in the Sandusky Mall, on March 19. This chain of optical stores was created in 1961 by Stanley Pearle in Savannah, Georgia. The store was known for offering one-hour eyeglass services at budget prices. The storefront was unique for the time, with an artistic style that screamed 1970s, complete with puffy padding, round-edged windows and bright colors. Even the eyewear display cases were rounded, reflecting the architecture of the day. In 1985, Stanley Pearle sold his stores to Grand Metropolitan. That company closed all underperforming stores in 1987, including the Sandusky location. With the space vacant, The Limited store next door decided to take the spot and expand into that retail space.

Interior retro eyewear displays.

327: THE LIMITED (1977–2017)

The Limited was one of the more popular women's clothing stores in the mall. Based in Columbus, Ohio, since 1963, the company had 151 stores nationwide at the time. It offered a wide section of fashions, from casual to formal wear. It even had accessories like scarves, jewelry and suntan lotion. Business was so good that in 1987, The Limited gobbled up location #325, expanding there after Pearle Vision vacated. The company exploded in sales throughout the 1980s and '90s, but by 2017, The Limited was left reeling from financial debt. It filed for Chapter 11 bankruptcy and close its stores.

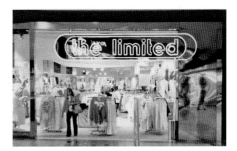

330: OSTERMAN JEWELERS (1977–2018)

Top: Osterman Jewelers interior.

Osterman Jewelers was another store lured away from Perkins Plaza to join the ranks of mall stores. The store was founded in Toledo, Ohio, by Lewis Osterman in 1928. His son took over the operation by 1977 and expanded into twenty-two locations. The Perkins Plaza location closed on February 7, and the store reopened in the mall on February 17.

They were one of the more popular jewelers in town. It carried the latest jewelry fashions and offered rings, watches and other jewelry for all occasions. Osterman Jewelers carried custom-made jewelry and imported its own diamonds to all their locations. That saved the company a lot of money. It was even the first jeweler to bring jade stones from China to the area. In 2018, cofounder William Osterman passed away. As a result, the company immediately downscaled and closed most of its locations.

340: KARMELKORN (1976–90)

Karmelkorn was created in 1929 by Karmelkorn Shoppes Inc., based in Rock Island, Illinois. It was one of the first stores to open in October 1976 and had 170 locations nationwide. The walls were painted with bright oranges, yellows and browns. Black and white colors were used for the trim to give the shop an overall inviting feel. Karmelkorn offered

many flavors of popcorn, including caramel, Cheesekorn, sour cream and Onionkorn. The establishment also offered items like popcorn balls,

homemade candies, Karmel apples, cotton candy and popcorn-shaped centerpieces for parties. When it came to offering fun Halloween- and Christmas-themed popcorn balls, Karmelkorn had you covered. The store even made special popcorn platters for the Super Bowl. In 1990, the owner decided to retire and sold his location. Space #340 would return in 1992 as the Corn Shoppe.

345: GRANNY'S COOKIES (1977–81); DAVID'S COOKIES (1984–85); CHERYL'S COOKIES (1985–96)

Granny's Cookies became the first cookie shop in a long line of cookie stores to occupy retail space #345. Founded in Pittsburgh, Pennsylvania, Granny's Cookies offered a dozen or so varieties of cookies, including chocolate chip, sugar cookies and more. You could even buy them in bulk. Holidays were a big time for Granny's Cookies, as it offered both Halloween and Christmas cookies during those respective holidays.

In 1981, the franchise owner wanted out of the cookie business and sold his location to David's Cookies from Cedar Grove, New Jersey, which reopened two years later. David's Cookies was named after founder David Leiderman. With ninety-two stores in existence at the time, the company offered a wide variety of cookies, including chocolate chip, peanut butter, chocolate chunk, oatmeal and macadamia nut. Cookies could be purchased individually, by the pound or in gift tins. Unfortunately, increasing operating costs forced David's Cookies to close unprofitable locations, including Sandusky's, in 1985.

Cheryl's Cookies from Columbus, Ohio, was next to take up the cookie mantle. The owner, Cheryl Hazelbaker, from Bellevue, Ohio, thrived for over ten years at that location. Eventually, she was able to sell her company to 1-800-Flowers for $55 million.

350: BancOhio (1978–84); First Buckeye Bank (1985–86)

BancOhio, founded in 1929, was Ohio's first and oldest bank-holding firm. The mall branch opened on March 20, 1978, becoming the company's fourth Sandusky location. The storefront was decorated with a wood-panel finish. A door to the left led inside, and a large deposit drop box was out front. Having a banking branch inside the mall was ideal for mall businesses; they could avoid having to travel far to make daily deposits. In the summer of 1984, BancOhio was sold to National City for $310 million, and all five branches were closed. First Buckeye Bank briefly took over the mall location next.

370: Duke & Duchess (1977–93)

Store #370 was originally going to be home to the hair-cutting chain Your Father's Mustache, but the deal fell through. Instead, Duke & Duchess from Steubenville, Ohio, became the second salon to open in the mall. Jim and Frank Luckino opened their first shop in 1974 and offered customers "quality and sleek designed" haircuts. They featured Roffler and NuVipa hair products and specialized in perms and hair coloring. In 1986, they expanded their operation to include tanning beds, which were quickly becoming all the rage. This only added to their success and helped them continue to be a mall staple for an amazing fifteen years before overhead costs became too much for the company to handle. The establishment closed in 1993.

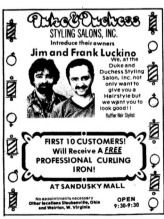

Top: Duke & Duchess interior.

390: MURRAY'S LAW OFFICE (1978–85)

Sandusky attorney Jerry B. Murray from Murray and Murray decided that having a storefront in the mall could help drum up business. Positioned at the back of the mall, this 1,200-square-foot space was turned into a dedicated law office featuring an office, a lounge, a library, a storage room and even an outer office complete with a working fireplace. In 1982, the location was greatly reduced in size to make way for the mall's fifth anchor store, BEST Products. The new layout caused Murray's square footage to be cut in half as the new mall entrance was shifted a few feet over into their retail space.

When Jerry Murray left in 1985, he had racked up $35,000 in unpaid lease bills. After his departure, the space sat vacant for more than five years until a cocktail lounge called Cheers took up residence in 1990. Named after the popular TV show of the same name, it served alcohol, soups and sandwiches.

400 BLOCK

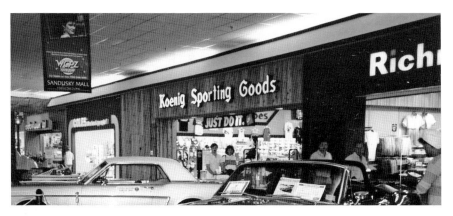

The 400 block of stores down the south wing, including (left to right) Craft n' Flower, Coles Bookstore, Koenig Sporting Goods and Richmond Brothers, 1983.

400: GOLD MINE: (1977–2009); BEST PRODUCTS (1982–97)

Gold Mine was a chain of video-game arcades owned by Nickels and Dimes Inc. of Lewisville, Texas. When the company opened its first location at the local Six Flags Mall in 1972, the concept of arcade games was just beginning. With only two games in existence at the time (Pong and Spacewar), Gold Mine actually started out by offering pinball and boardwalk games for customers to play. Once arcade games began exploding onto the scene by 1976, Gold Mine was able to expand just as fast into many malls across the country. When the company began negotiations with Cafaro, it originally set its sights on space #405 but moved to #400 instead, since the space was slightly larger.

The most memorable feature of Gold Mine was the storefront's resemblance to an actual gold mine. Huge rocks decorated the outside, and a doorway resembling a mineshaft led into into a dimly lit arcade room with huge wooden beams running up and down the ceiling to further sell the mining atmosphere. The name *Gold Mine* itself was of course a play on words; kids needed to put money into a change machine, which then spat out gold tokens on which the games operated.

In 1977, Gold Mine boasted of having more than eighty arcade games under one roof. "You can play the silver ball, drive a race car or bowl a few lanes at the Gold Mine," one press release stated. A long row of pinball machines stretched along the back right corner wall for the pinball wizards. Gold Mine became so popular that it opened another arcade in 1979 in Cedar Point off the main concourse. It remains today. Over the years, the company stocked the latest and greatest games hitting the arcade scene, from Space Invaders to Pac-Man to Mortal Kombat. In the late 1980s, it was the only place in town that had the four-player Teenage Mutant Ninja Turtles arcade game. You could jump on the game and play with three strangers beside you and become instant friends by the end of the adventure. In 1990, Gold Mine was the first location in northwest Ohio to have the 3D hologram arcade game Time Traveler. (The price was a hefty $1.00 per play!) Later in the '90s, Gold Mine had the hit four-player Gauntlet Legends. The game actually stored your character, and a quick password allowed you to pick up where you left off.

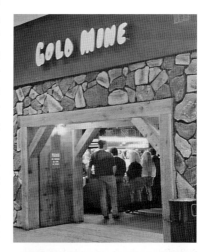

The craziest thing to happen at Gold Mine occurred in 1981, when district manager James Kent was caught removing arcade machines from the shop and reporting them as "mysteriously disappeared." He would place them

Middle: Gold Mine interior featuring a mining atmosphere. *Bottom*: Kids playing the latest video games, including Pac-Man, Galaga, Dig Dug and more.

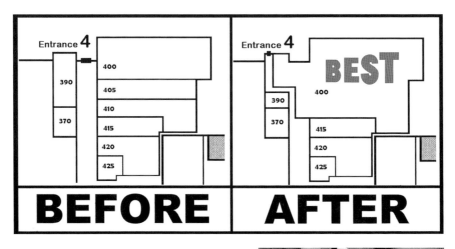

in hotel lobbies around town to collect revenue from them. Kent was charged with $25,000 in damages.

If you don't recall Gold Mine being at location #400, well, that's because in 1984, Gold Mine was relocated to retail space #583 in order to make room for a fifth anchor store that entered the mall that year, BEST Products. Gold Mine endured a long time at the new spot and was rebranded in 1993 as Tilt.

BEST Products entered into space #400 next in 1984. The entire back half of the mall had to be reconfigured to fit this new anchor store. BEST took up spots #400, #405, #410 and even the back mall entrance area, since it had to be shifted a few feet over into retail spot #390. This Richmond, Virginia company founded in 1956 had 188 stores under its belt at the time, but this location would be the first built inside of a mall. The shopping experience at BEST was a bit different than at your

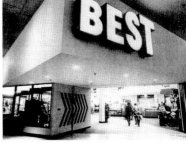

Most of the 14,500 items at Best are in display cases.

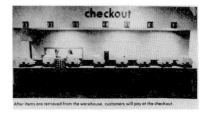

After items are retrieved from the warehouse, customers will pay at the checkout.

run-of-the-mill store. First, every item in the store was placed in a glass display case. If you wanted to purchase an item, you had to grab a ticket,

write down the item number, take it to the checkout counter and then wait for the item to roll down a conveyer belt. This was because the entire inventory was stored in a warehouse behind the checkout counter. (And this author knows from personal experience how exhausting working the stockroom was back then!) The process of taking a ticket to the counter and waiting for the item to arrive took from five to ten minutes. It is a concept that probably wouldn't work in today's retail market, but BEST was able to pull it off in the 1980s.

BEST Products opened on September 10, complete with a ribbon-cutting ceremony. At the time, the company had 100 stores nationwide and sales surpassing $1 billion. The company carried about 14,500 items spanning many departments, from electronics, jewelry and housewares to luggage and toys. By 1996, the company started feeling pressure from larger supermarkets moving into the area and filed for Chapter 11 bankruptcy that October. Since BEST Products had been a longtime mall staple, many considered its closure the end of the old mall era. BEST Products closed in January 1997.

405: Jaycee's Haunted House (1979–81)

The Sandusky Mall never leased out spaces #405 or #410 to any retail store, because they were located in low-traffic areas. Because of this, the mall decided to use these spaces as part of its Halloween celebration, which quickly became a hit in 1978. In 1979, the mall opened a new haunted house attraction, operated by the Jaycees, who started the trend of staging haunted attractions in abandoned buildings in the early 1970s. The Sandusky chapter had previously operated other haunted houses starting in 1971 in schools, hospitals and other institutions. By 1979, the Jaycees decided to stage a haunted house in a vacant mall location and did so in style. The storefront was covered with a large spooky castle made from painted plywood. On

Top: Haunted House entrance.

the inside, customers traversed fourteen spooky rooms. Each had its own terrifying Halloween theme, including hospital frights, blood altars, *Pit and the Pendulum* scenes and homages to *The Texas Chainsaw Massacre*. The event (October 20–October 31) ran from 6:30 p.m. to 9:30 p.m.

The event was so successful that the Jaycees returned in 1980 and 1981. After every season, the group donated more than $5,000 to the local hospital. The Jaycees did not return in 1982, because retail spaces #405 and #410 were used to bring BEST Products into the mall.

415: PETLAND (1979–92)

Petland was a chain of pet stores founded in 1967 out of Chillicothe, Ohio. It carried everything you could want in a pet supply store, including complete lines of aquariums, small-animal cages, bird cages, bedding, food and so much more. Petland touted itself as a full-service pet store, and for good reason! The right-hand side of the store was utilized as a kennel, with a wall of windows displaying puppies or kittens for sale. The middle of the store had displays of caged birds and aquariums filled with mice, rodents, ferrets and more.

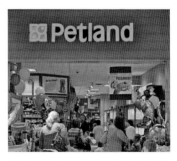

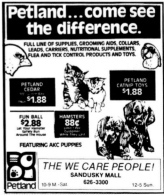

The back of the store was dimly lit for the wall of fish aquariums housing hundreds of varieties of both freshwater and saltwater fish. By 1983, the store even had parrots in the front. They were very friendly to

costumers. The staff was trained on giving tips on how to care for animals. Over the years, many concerns were raised about the sale of animals, specifically regarding the use of puppy mills. The company had to assure the public almost yearly that their puppies were registered with the American Kennel Club (AKC). Another concern was the sale of animals deemed too dangerous, such as snakes and lizards. Things got so crazy that in 1979, Rhode Island passed a law to keep pet stores from selling such animals.

420: Holman's Jewelry (1978–84); Sheiban's Jewelers (1984–87); Christmas Gallery (1989)

Holman's, based in Norwalk, Ohio, was the fourth jewelry store to move into the mall. It carried not only high-ticket items, but also cheaper products like $9 LED watches, $33 dining sets and faux gold jewelry. In 1981, Holman's suffered a major blow when founder William Mann passed away. Also that year, one of the store's managers was caught stealing $85,000 worth of merchandise and was taken to court. Mann's son took over the business and began closing down locations in order to close the franchise and liquidate assets. In 1984, the Sandusky location closed.

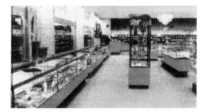

That November, Sheiban's Jewelers replaced Holman's. This Strongsville, Ohio franchise was a small chain of just three stores. The store offered the finest in rare stones, watches and giftware.

Once Sheiban's went out of business, the Christmas Gallery, which had occupied retail space #490 in the 1987 and '88 holiday seasons, took up temporary residence to sell Christmas products in this new location.

Don Richardson, Sheiban Jewelers manager.

Top: Holman's Jewelry interior. *Middle*: Sheiban's Jewelry storefront, 1984–87.

425: BOOKLEIN (1977–99)

Booklein arrived in October 1977 to become the retail chain's fifth store. This North Olmstead business, begun in 1971, was Sandusky Mall's third bookstore, but Booklein was considered to be more of a newsstand. It carried all of the local newspapers as well as hundreds of magazine titles. In fact, it pretty much carried every magazine in publication. If you needed a hard-to-find magazine, odds were good that Booklein had it. The store had rows and rows of magazine and comic book racks and even an area for best-selling books of the day. Perhaps the biggest event to hit Booklein was when an issue of *Weekly World News* hit newsstands in 1993 featuring the Lake Erie Monster. The issue was a big seller, and Booklein was one of the few places that carried the magazine. It sold out within minutes.

The other unique feature Booklein was known for was its huge selection of fine cigars, cigarettes, tobacco and pipes. These items were stored within a huge glass enclosure located at the back left-hand side of the store. The store carried many hard-to-find blends and, as a bonus, even offered to blend different tobaccos together on-site for costumers.

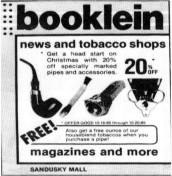

Left: The *Weekly World News* cover of the Lake Erie Monster edition.

432: Hot Sam (1976–95)

Hot Sam was one of the first snack vendors to enter the mall in 1976 and specialized in making Dutch-style hot pretzels that were "baked fresh every three minutes." You could get a variety of toppings, including cheese, pizza toppings, cream cheese and even chocolate if you dared. Hot Sam also offered nacho chips and cheese alongside various soft drinks. This little pretzel shop was founded by Julius Young in 1968 and hailed from Troy, Michigan. At the time, it had 130 shops in service and was the only pretzel game in town. All that changed in the 1990s, when Auntie Anne's pretzel shops became insanely popular and overtook Hot Sam. In the end, Hot Sam sold the company to Auntie Anne's, and all locations were either rebranded or closed by 1995.

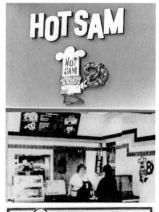

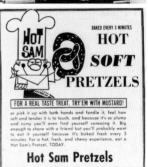

435: Baskin Robbins (1977–91)

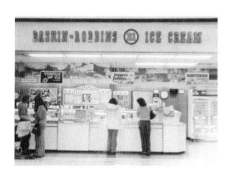

Baskin Robbins was the ultimate one-stop shop for ice cream cravings. This franchise of ice cream parlors began in 1945 in California. As the story goes, during a World War II tour in the South Pacific, two men used a freezer from an aircraft carrier to make ice cream and employed the weirdest food combinations to feed their crewman. Everyone loved the odd flavors so much that the two men decided to mass-produce their creations by starting their own business. By 1972, their franchise had sold over sixteen million gallons of ice cream.

Left: Baskin Robbins interior, with Diane Wahl.
Right: Baskin Robbins interior.

Baskin Robbins is famous for serving up thirty-one different favors, but it was more like forty flavors after adding in the specials and the flavors of the month that were rotated in and out. The most popular flavor was chocolate mint. Baskin Robbins also carried vanilla, chocolate, strawberry, cookie dough, mint chocolate chip, rocky road, black cherry, pistachio and more. I'm hard-pressed to remember all thirty-one flavors, but the store once carried a multicolored, sherbet-flavored ice cream streaked with every color of the rainbow, called Superman. Among the rare flavors of the month were banana rum, black walnut, fluffer-nut, English toffee, banana cake, banana marshmallow and pink bubble gum. They even had toppings of pineapple, orange, marshmallow, chocolate and hot butterscotch. Didn't want ice cream? Well, they also had frozen yogurt, turtle pie and Bavarian cake.

In March 1991, the owner retired from his business, closed his store and sold the retail space to Et Cetra Ice Cream, which opened in 1992.

437: BATTER-UP SNACKS (1977–84); HOT DOG CORNER (1986–92)

Batter-Up Snacks was a locally owned business offering customers a hot dog on a stick—or, as they called it, a baseball bat. This sports idea helped the company come up with the name, Batter-Up Snacks. The store offered not only hot dogs on a bat, but also cheese on a bat, zucchini on a bat and French fries (thankfully not on a bat). This small food stand occupied just 312 square feet and made food in front of the customer upon ordering. Batter-Up Snacks lasted a good seven years before leaving the mall.

Hot Dog Corner arrived two years later. It was another local business offering shoppers many hot dog options, from all-beef dogs to chili dogs. Customers could get chips and a drink and take a lunch break from shopping.

440: FATHER & SON SHOES (1977–92)

Father & Son Shoes was one of the first five shoe stores to grace the Sandusky Mall. It was a division of Endicott-Johnson Shoe Corp. based in Endicott, New York. The company was founded in 1922 and had over two hundred stores in operation. This shoe store catered only to men and boys and carried all the latest fashions in casual shoes, sports shoes, dress shoes and even slippers. Father & Son Shoes was located in a prime spot in the mall and enjoyed twenty-five years of service. The store chose not to renew its lease in 1992 and closed that March. Babbage's leased the space next, in 1992, followed by GameStop in 2003.

450: SUSIE'S CASUALS (1977–92)

Susie's Casuals was one of the many women's apparel stores in the mall. It focused on selling a wide variety of casual wear for the junior woman, including dresses and sportswear. Based out of New York, this small chain of stores owned by Kinney Shoes was just getting started when it entered in 1977. After thriving for twenty-five years, the store closed in 1992 due to economic difficulties. The entire company went belly-up six years later. The retail space became Northern Reflections in 1993 and then Pac-Sun in 2002.

455: KINNEY SHOES (1977–98)

Kinney Shoes was one of the five shoe stores that began operations just in time for the mall's grand opening. It was based out of New York and founded in 1894. By 1978, Kinney Shoes held the distinction of being the largest chain of shoe stores in the country. Kinney Shoes

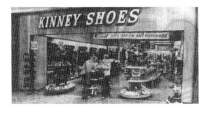

had a fully trained staff to sell shoes to the whole family. The company held itself to very high standards and had experts scouring marketplaces in Europe, South America and Asia to find the highest-quality shoes. Kinney would then have its seventeen factories churn out thousands of shoes a day.

As the company entered the 1990s, it began experiencing major financial woes. Its sister company, Foot Locker, was outperforming Kinney in sales by 70 percent, so Kinney decided to rebrand all Kinney Shoes as Foot Quarters. It was able to hang on for six more years before the company shuttered all 467 locations.

460: LERNER (1977–2003)

Lerner was one of the more popular women's clothing stores in the mall, offering "casual to dress up clothes and everything in between." Based

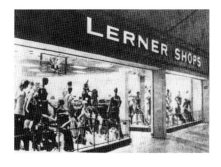

in New York City, the company was founded in 1918 and operated 479 stores at the time. Lerner carried the latest fashions when it came to women's tops, pants, dresses, suit pants and more. Lerner was also big on using mannequins in front of the store to draw in costumers. In 1985, Lerner was acquired by The Limited.

The company continued to succeed well into the 2000s, with sales reaching almost $1 billion. Since The Limited was on a winning streak, it decided to phase out all Lerner locations and closed the Sandusky store in 2003 when the lease expired.

470: CRAFT-N-FLOWER WORLD (1977–92)

Craft-N-Flower World was dubbed "Your unique and complete craft and floral center." Based in Akron, Ohio, this chain of craft stores founded in 1973 had two locations. The store had pretty much everything you could ask for in the crafting world, including, foam, wood, art kits, ceramic pottery and more. It also 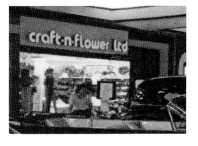 sold a large variety of live plants, including many varieties of flowers for all special occasions.

475: COLES BOOKS (1977–92)

Coles Books was the second bookstore to grace the Sandusky Mall. The store was founded in 1940 by the Cole brothers in Toronto, Canada. In 1977, it was the largest bookstore chain in Canada with 110 stores and many more expanding into the U.S. market. What made the chain so popular was that it reprinted old and rare out-of-print books that were in high demand. It also offered a wide variety of hardback, paperback and children's books. The front area was reserved for magazines and new releases; older titles were in the back. Coles also did a lot of work for the community, donating many books and

Above, right: Cole Books interior, featuring local author
Alan Diede.

magazines to local book fairs and holding local
author book signings on a regular basis.

In 1992, Coles began closing underperforming
stores, including the Sandusky location that
year. In 1995, the company merged with Smith
Books, which then merged with Barnes and
Noble. The vacant bookstore became a music
store called NRM in 1992, then Waves Music
in 1998.

480: ROBERT HALL (1977);
HOTY SPORTING GOODS (1978); KOENIG SPORTS (1979–97)

If you're having a hard time trying to remember Robert Hall, don't feel too
bad. It was the first store to close in the mall. Robert Hall briefly held the
distinction of being the largest retail family clothing chain in the country.
The company started in 1941 and, by 1960, had amassed 335 stores. When
it came to clothing, Robert Hall had just about everything one could ask for
at rock-bottom prices. The store had sections for each member of the family,
including a big-and-tall section. Unfortunately, the retail chain lasted only
three months before the owner, United Merchants & Manufacturers Inc.,
was hit with a $41 million loss of revenue in 1976. This forced ownership
to close 100 stores, including the Sandusky location. After Robert Hall left,
Cafaro had a hard time selling the large retail space. The decision was made
to break up the site into two smaller retail spaces, and #485 was born.

Hoty Sporting Goods leased out the left side in early 1978. This retail
chain of sporting-goods supplies was based in Lakewood, Ohio and named

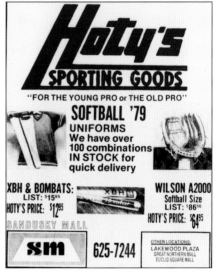

Top left: Robert Hall storefront, 1977. *Top right*: Hoty's storefront, 1978. *Bottom left*: Koenig Sports storefront, 1979–91.

after owner, Angelo Hoty. This was its third location. Sales were so good for the company that Hoty sold his company for a large sum to Koenig Sports of Willoughby, Ohio, in the summer of 1979. Koenig worked with local schools in the area, mainly by supporting Little League programs. After almost twenty years, the sports company ran into financial problems and began closing underperforming stores. By 2000, the company had filed for bankruptcy and then went out of business.

485: RICHMAN BROTHERS (1978–92)

Taking up residency in the newly created #485 spot was Richman Brothers. Before moving to the mall, Richmond Brothers was located at 415 West Perkins Avenue, across form Bonnie Lanes. The company had three hundred retail stores by 1978 and was owned by Woolworth. Richman

Brothers catered to the businessman and offered the finest menswear at prices that couldn't be beat. The store carried suits, sport coats, slacks, ties and even jeans for the casual businessman. It even claimed to have seven hundred fussy tailors working for the company, which meant quality for the customer.

Woolworth began running into financial problems in the early 1990s, and this greatly impacted Richman Brothers. The entire chain was closed in 1992, just months prior to Woolworth also going belly-up.

490: ACTION HARDWARE (1977–81); ANGELO'S (1982–85); CHRISTMAS GALLERY (1987–88)

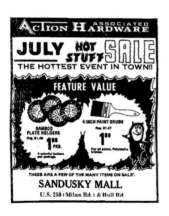

Action Hardware was based in Cheswick, Pennsylvania. Founded in 1972, it was the only hardware store to grace the Sandusky Mall. At the time, the company owned twenty-eight stores and offered a wide variety of paint, electrical items, tools, housewares and more. The owner chose the name *Action Hardware* because he wanted to be listed first in the phonebook. The eight-thousand-square-foot store had a pretty uneventful four-year run at the mall, but it finally closed in September 1981 due to sluggish sales and increasing overhead costs. The company itself was able to last until 2005.

Angelo's Restaurant arrived on the scene next and served as the mall's full-service Italian cuisine restaurant. It offered many pasta, steak and seafood dishes. Angelo's opened on October 8, 1982, and featured a huge bar area that remained open until 2:00 a.m. The bar was decked out with big-

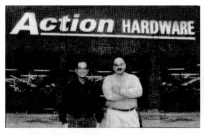

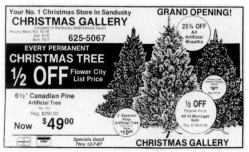
screen TVs, which attracted sports fans on Sundays. The restaurant even held a "Farewell to M.A.S.H. Party" so that fans of the hit show could watch the last episode together when it aired in 1983.

Toward the end of Angelo's tenure, it was losing a lot of money. As one employee put it, the staff was sneaking more drinks than the restaurant sold and drank them out of business. After it closed, rumors swirled that TGI Fridays would be replacing Angelo's, but that was false. It took the mall a long time to find a replacement, as the retail space was large.

There was talk of splitting the location up into separate stores, but thankfully, that holiday season, the Christmas Gallery retail chain expressed interest in setting up a temporary store there. It opened around Christmas time and sold everything from Christmas trees, lights and ribbons to candles and more. Sales were so good that it returned in 1988. In 1989, however, the company was forced to lease out retail space #420, because Cafaro Co. finally found a tenant, Northeast Appliance Center, to fill the space. The company, from Pittsburgh, Pennsylvania, had fifty-one locations in operation selling a wide variety of electronics. It lasted until 1992.

500 BLOCK

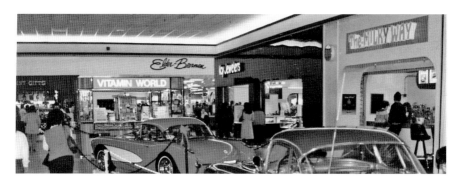

Stores in the 500 block, including (*left to right*) Cedar Point Gifts, Elder Beerman, Kay Jewelers and Milky Way, 1985.

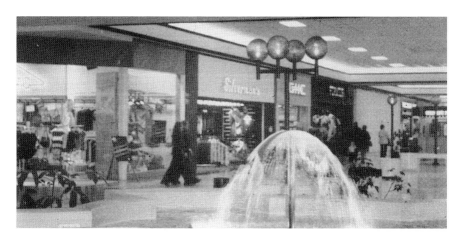

The 500 block of stores, including (*left to right*) Ragazza, Silverman's, GNC, Foxmoor, a boarded-up entrance to the future May Co. and Bottom Half.

505: HICKORY FARMS (1977–88); MR. BULKY'S (1989)

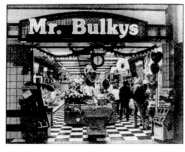

Based out of Toledo, Ohio, Hickory Farms was founded by Richard K. Ransom in 1951. By 1977, the company owned an impressive 356 stores countrywide. It carried the best selection of beefs and cheeses in the country, including beef sticks, over 126 types of cheese, cheese wheels, crackers, mustards and jams. Every day they had trays of samples on hand located around the store to customers to snack on. You could even ask for a sales tour of the store to view the entire collection. Hickory Farms lasted eleven years and closed only because it found that 70 percent of its business came from Christmas sales. In order to save a fortune on overhead costs, the company closed all of its storefronts and signed multiyear deals on leasing mall kiosks around the holidays. This business model worked so well that Hickory Farms continues the trend today.

Mr. Bulky's based in Troy, Michigan, arrived in 1989. The company had thirty other stores and offered shoppers a wide variety of snacks in rows of bins out of which customers scooped out items and purchased. Instead of offering only candy and nuts like other bin stores, Mr. Bulky's carried all sorts of household items found in general stores of yesteryear. This included chocolates, spices, coffees, baking goods, pastas and more. The shop didn't last long, due to overhead costs. Sports Express took over the spot in 1990, then Christmas Shoppe in 1997, followed by Cheers in 1999.

507: SHOE SHANTY (1979–86);
UNIVERSE & OTHER TOYS (1987)

Retail space #507 didn't exist before 1979, because this area was originally intended to be one of the indoor entrances to May Co. Once that store was built, May Co. decided the extra entrance wasn't needed, and Cafaro decided to build another retail location in its place.

Shoe Shanty was the first tenant. Previously located at the Huron Plaza since 1975, the store carried all the latest fashions in shoes and boots for the whole family, but mainly for women. From casual, sports, dress and work shoes to even Western-style boots, it offered a huge selection to customers. In 1986, Shoe Shanty fell behind on vender payments, causing Western Shoe Company to file a lawsuit to recoup the $11,000 it was owed. The store fell into bankruptcy and closed.

When Shoe Shanty vacated, one of the most controversial stores to grace the Sandusky Mall entered that holiday season of 1987. Universe & Other Toys was a temporary seasonal store selling secular items like healing crystals and New Age books. It even offered psychic readings. Since the store was placed directly across from Zondervan's Christian store, this did not sit well with the shopping crowd. Costumers were so upset that they filed numerous complaints to the mall office. Soon, the new store was forced to shut its doors as a result of all the complaints. The question of whether or not this was the right decision became such a hot topic for debate that the local newspaper covered the whole fiasco for months. The Sandusky Register kept getting flooded with mail from residents voicing their opinions on both sides of the argument. It was a heated debated for months after the store was gone.

510: CAPTAIN CHIPS POTATO SHIP (1977–78);
HOUSE OF VISION (1979–82); E.B. BROWN (1982–98)

Captain Chips Potato Ship entered in 1977 right after Christmas. At the time, the company had seventeen other restaurant locations in Michigan and Ohio. The family restaurant seated fifty people. The decor featured many nautical items. A full-service snack bar was in the back corner. The

standout feature of Captain Chips was a large wooden ship motif surrounded by sail-boating items. As for the menu, the restaurant offered shrimp and clams, hamburgers, hot dogs, kielbasa and soft drinks. It also was the only place that made fresh potato chips on-site. Unfortunately the Chip Ship didn't catch on, and it was forced to sail into the sunset at the end of 1978.

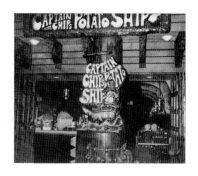

House of Vision arrived next, bringing a second eyeglass store to the mall. Based in Chicago since 1938, it carried all the latest fashions in frames and eyewear. By 1981, the company hit rocky waters after it evicted lead optometrist Terence Templeton from the store. He filed a lawsuit for unlawful termination. That sealed the fate of House of Vision, which went out of business in 1982. It was quickly replaced by E.B. Brown, another eyeglass shop, from Cleveland, Ohio.

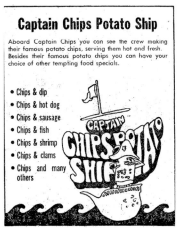

Captain Chips Potato Ship

Aboard Captain Chips you can see the crew making their famous potato chips, serving them hot and fresh. Besides their famous potato chips you can have your choice of other tempting food specials.

- Chips & dip
- Chips & hot dog
- Chips & sausage
- Chips & fish
- Chips & shrimp
- Chips & clams
- Chips and many others

512: CHARLIE CHAN (1977–84); THE MILKY WAY (1985); BUCKEYE & WOLVERINE SHOP (1986–92)

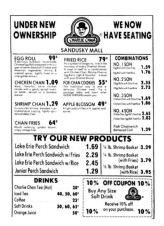

Charlie Chan was a chain of Chinese restaurants based on a series of twenty-two Charlie Chan movies made by Hollywood beginning in 1922. In the movies, Chan was China's greatest detective on the silver screen. He became such a popular icon that this chain of Chinese food restaurants, founded in Dayton, Ohio, used the character's name and likeness for the franchise. When Sandusky received one of the restaurants, the actor portraying Charlie Chan actually made an appearance on opening day to give away one hundred free Charlie Chan T-shirts.

Left: Charlie Chan storefront, 1977. *Right*: The 512 location became The Milky Way in 1985.

The Chinese food stand served up fast-food Chinese cuisine with some witty dish names. You could order the popular fish "Chan-wich" or the deep-fried shrimp dubbed the "Shrimp Chan." With food puns like these, you could always "Chan" your way through lunch. In 1981, Charlie Chan added a seating area in front of the shop. Unfortunately, in 1984, the company was "Chan-destined" to file for bankruptcy and closed all of its locations but one.

The Milky Way arrived next, in 1985. This small sandwich and soup shop was locally owned and provided a vegetarian option to shoppers. It didn't last long, however, due to high overhead costs. It closed up shop and moved to the Perkins Plaza.

The Buckeye & Wolverine Shop opened next. The company, based in Toledo, Ohio, had four locations in operation and offered a wide range of football-branded products from both the Ohio State and Michigan sports teams. This included coats, scarfs, chairs, lamps, bowls, flags and more. When the Cleveland Browns went to the playoffs in 1987, the store began to carry the team's merchandise, which became a big seller.

515: JB ROBINSON (1977); KAY JEWELERS (1979–86)

JB Robinson was one of the three jewelry stores occupying the mall for the grand opening. Based in Cleveland, Ohio, with twenty-three stores at the time, JB Robinson offered

a wide selection of jewelry at low prices. Unfortunately, it was the second store to leave the mall, following Robert Hall in late 1977.

Kay Jewelers quickly snatched up the vacant location and opened on October 20, 1977. Founded in 1916, the company hailed from Reading, Pennsylvania. Kay offered many jewelry items but focused more on gifts for women like necklaces, earrings and rings. Kay had two hundred stores at the time. The Sandusky location lasted more eight years before being replaced by Alvin's Jewelers in 1986.

530: BERNARD WIGS (1977–80); CHIC WIGS (1981–2005)

Bernard Wigs, founded in Detroit, Michigan, had been operating since the mid-1960s and had around thirty locations at the time. The store carried a large selection of wigs of all sizes and colors that were synthetically handcrafted. Often, when a particular Hollywood starlet rose to fame, such as Farrah Fawcett, Bernard was quick to sell a wig style of that star's haircut. Unfortunately, Bernard Wigs closed in 1980, when the company shut down unprofitable stores. Two years later, the entire company went belly-up and filed for bankruptcy.

Chic Wigs moved in next. The company owned forty-three locations and filled the void Bernard left behind. According to the manager, Betty Redder, "People have told me how glad they are to have a wig store in Sandusky again. Some were starting to panic because there is a real need for wigs in chemotherapy patients." Each employee was professionally trained from the company's headquarters in New York. They could sell, style and clean wigs. The store also sculptured nails and eyebrows, pierced ears and sold jewelry.

535: FANNY FARMER (1976–94)

Fanny Farmer was one of the six original snack locations that entered the mall in 1976. This Rochester, New York company started in 1919 and grew to number 350 locations by 1977. Fanny Farmer carried hundreds of types of chocolates, fudge and more. You could purchase them by the piece or boxed in bulk. Every piece of candy was made with quality ingredients from old-time recipes. The store even offered new recipes featuring sugarless and diet candies. The walls were decorated with brown-and-white-striped wallpaper to give it an old-time feel. In 1992, the Archibald Candy Co. bought the company and began closing underperforming stores, dooming the Sandusky location in 1994.

500: MAY CO. (1979–93); KAUFFMAN'S (1993–2006);
MACY'S (2006–17)

Retail space #500 was an anchor location originally reserved for Carlisle Allen. Unfortunately, that company backed out at the last minute, screwing up the timetable for the mall's construction. Since anchor stores weren't built until a tenant was securely in place, the rest of the mall was built around lot #500 until Cafaro could find a replacement. They first turned to Sears. For a while, it looked like Sears would be the tenant, but negotiations fell through. Cafaro then turned to May Co., and a deal was struck. As the retail space was being built, the construction process was constantly plagued by bad weather, from tornado damage to icy blizzards. The original opening date of 1977 kept being pushed back drastically to March 2, 1979. The

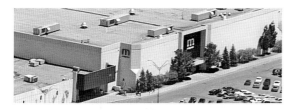

May Co. anchor store exterior, 1980.

entire project cost $2.2 million, and the store became the company's eleventh location. Five days before the grand opening, the company held a private gala with executives and VIPs in attendance. Guests were treated to gourmet food, champagne and hors d'oeuvres.

The 135,000-square-foot retail space was the only two-level store in the mall. It was also the only store with a double-insulated roof. Clothes and fashions took center stage on the first floor, while furniture, TVs, stereos, kitchen appliances and dinnerware were featured on the second floor. There was even a Three Crowns Restaurant on the second floor, with an entrance that featured a skylight atrium surrounded by mirrored columns. Unfortunately, the underperforming restaurant closed in 1986.

In October 1992, May Company went through a merger that forced all stores to be rebranded as Kaufmann's. Everything remained the same inside the store, but their signage was switched out. On the outside, the May Co. sign was taken down from the side of the building and replaced with the Kaufmann's logo just above the entrance doorway. It should be noted that when the May Co. sign was taken down, Kaufmann's never bothered painting over it. The eerie outline of the May Co. letters remained etched on the building wall for many years, serving as a haunting echo of the store that once was.

In 2005, another corporate merger took place, causing the store to rebrand yet again, as Macy's. In September 2006, new Macy's signage was hung outside, and the haunting May Co. letters were finally painted over. In January 2017, Macy's announced that it was closing one hundred underperforming locations,

included Sandusky's. This took everyone by surprise, especially the store manager, who thought that everything was fine. The store closed in March 2017, leaving J.C. Penney as the final anchor store in the mall.

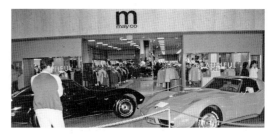

540: THOM MCAN (1977–85); LEATHER LTD. (1985–92)

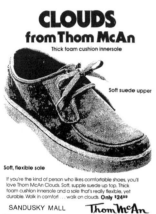

CLOUDS
from Thom McAn
Thick foam cushion innersole

Soft suede upper

Soft, flexible sole

If you're the kind of person who likes comfortable shoes, you'll love Thom McAn Clouds. Soft, supple suede up top. Thick foam cushion innersole and a sole that's really flexible, yet durable. Walk in comfort … walk on clouds. **Only $24⁹⁹**

SANDUSKY MALL *Thom McAn*

Thom McAn originally had a store on Cleveland Road and moved into the mall in 1977. This New York–based company, founded in 1922, had over 1,500 locations, becoming the fourth-largest shoe retailer at the time. Within 1,068 square feet of retail space, the store sold a wide variety of men's shoes. Thom McAn produced its own line of shoes, ranging from leather, dress and leisure to sport and casual. The store also sold work shoes and boots. The company even created a sister brand of shoes, Jox, which was a higher-quality athletic shoe. In 1985, the company closed seventy-five underperforming locations, including the Sandusky store.

Next, Leather Ltd. entered this prime location, offering assorted leather goods, including coats, boots, jackets, belts, wallets and more for both men and women. Leather Ltd. closed in 1992 due to economic difficulties. The location then became home to Excalibur Gifts in 1992.

545: NATURALIZER SHOES (1977–95)

Naturalizer Shoes was the sixth shoe store in succession to enter the Sandusky Mall. The store touted itself as carrying higher quality women's shoes that were "the perfect fit" over the competition. According to manager Harold Herron, "We carry sizes no one else carries, from very narrow to very wide." It carried all the latest fashions, even in leather sandals, boots and purses. In the 1990s, the company stopped renewing leases on unprofitable stores, closing the Sandusky location.

ANNIVERSARY SPECIAL

Two of the best fitting year around patterns. Taken from regular stock to mark our anniversary.

DOVER

Both styles in brown, camel, black and navy.

TUSCANY

THURSDAY THROUGH SUNDAY ONLY!

Both Styles
reg. $44⁰⁰
NOW **$29⁹⁴**

naturalizer
SHOE STORE

550: BOTTOM HALF (1977–81); LITTLE WORLD (1982–93)

Bottom Half was founded in Cincinnati, Ohio, and had amassed eighty-one locations in only seven years of operating. This aptly named retail chain carried hundreds of pants fashions catering to teens and college-aged women and men. The store carried all the popular fashions offered by Levi's, Jordache, Sundowner, Kensington, Sergio Valente, French Star and Britannia, among others. The company also had its own brand of pants, which included painter pants, coordinating tops and accessories. The stores were decorated with red carpet and red-and-white checkerboard wallpaper and had red plastic bags to match. In 1981, the company closed all underperforming locations, including Sandusky's.

Little World replaced Bottom Half in April 1982. It carried collectable dolls, statues and porcelain collectable figurine lines like Precious Moments and Hummel, which were huge in the 1980s. The store lasted for eleven years before going out of business. It was replaced by After Thoughts in 1993.

565: FOXMOOR (1977–88); DOLLAR TREE (1988–94)

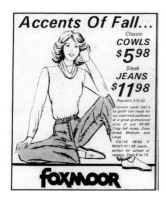

Foxmoor was one of the many women's apparel stores that entered the mall in 1977. At the time, the company had 363 stores. Based in Harrison, New York, Foxmoor catered to the fashion-minded junior woman and focused on selling sportswear, which made up 75 percent of all sales. The store also carried a variety of casual and dress clothes. Foxmoor offered a rustic, country-style setting for shoppers. In the late 1980s, Foxmoor ran into financial troubles

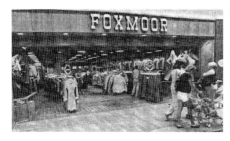 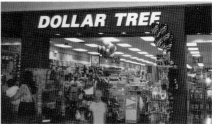

Left: The Foxmoor storefront in 1977. *Right*: The 565 location became Dollar Tree in 1988.

and closed all underperforming stores, including the Sandusky location in 1988. The company filed for Chapter 11 bankruptcy in 1990.

In September, it was announced that a new concept store, Only $1.00 (which changed its name to Dollar Tree before opening), would grace the mall. Everything in the store sold for a dollar, a gimmick that had never been done before. In order to keep prices down, the store only accepted cash. When the store opened, people were shocked at just how many items it carried. Dollar Tree had a rocky start, as store supervisor Angel Merritt was arrested for stealing bank deposits. After that hurdle, however, the store found success in Sandusky. It left the mall in 2006 for a new location in the newly built Crossings of Sandusky Plaza.

570: GNC (1977–2020)

General Nutrition Center (GNC) was a health-food store based in Pittsburgh, Pennsylvania. Sandusky's store would become the company's

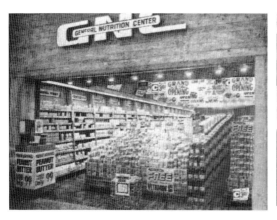

Left: GNC sets up for the mall grand opening celebration, 1977.

five hundredth location, which was quite a milestone. The company had been around since 1909, making it one of the oldest health and diet chain stores around. GNC provided customers with a huge selection of supplements and natural food sources without pesticides, artificial flavors, chemical additives or preservatives. When it opened, it offered fresh food, including fruits, nuts, cereals, eggs, juices, flour and more. GNC filed for Chapter 11 bankruptcy in June 2020, which closed the Sandusky location for good. It was the mall's second-longest tenant, right behind J.C. Penney.

580: SILVERMAN'S (1977–92)

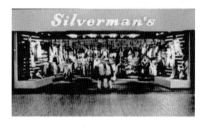

Silverman's, from Oakdale, Pennsylvania, was an eighty-five-year-old company by the time it reached the Sandusky Mall. It offered all the latest fashions for men, including slacks, suits, casual coordinates and finer suits. It also carried a complete line of ties. All of its clothes were separated and arranged in coordinated groupings to make shopping easier for the consumer. In 1992, Silverman's was sold off and rebranded as Attivo.

582: RAGAZZA (1977–79); KARA TEES (1982–84); MR. FORMAL'S TUXEDO (1986); ROYAL OPTICAL (1986–92)

583: GOLD MINE (1981–2009)

Ragazza catered to today's modern junior businesswoman, carrying a wide range of business wear. This included three-piece suits, blazers, pants, vests and dresses, as well as sportswear, swimwear, tube tops, scarves and more. The store was owned by F.W. Uhlman and Company out of Bowling Green, Ohio. The Sandusky location became its first store to open in Ohio. Ragazza was given a factory-type look, complete with an open ceiling, exposed fixtures and the color red found in everything from carpets to walls. This was done because the logo was a red coat hanger. Unfortunately, after only two years of operation, Ragazza went bankrupt.

Cafaro Co. decided to split the retail space into two smaller locations after Ragazza left, since the waiting list for smaller retail stores was growing. Gold Mine leased the right-hand space in 1981. The arcade had been forced to move to this location from space #400 because BEST Products needed the extra space to become the mall's fifth anchor store.

Leasing out the left side was Kara Tees, a T-shirt store based in Columbus. The company had only a few stores in existence, but it offered a large variety of shirts that could be personalized from a gigantic selection of heat-transfer images. The store offered hundreds of the latest pop-culture images, from TV shows to movies and personalities, including *The Dukes of Hazard*; *Magnum, P.I.*; *E.T.*; the Fonz and more.

Mr. Formal's Tuxedo briefly took up residency next, in 1986, for only a month. Royal Optical eyewear then followed right behind.

585: MALL CINEMA (1977–93)

Before the Mall Cinema was built, Sandusky residents really had just one choice for seeing movies in what was considered a modern theater by today's standards, and that was Cinema World, located behind the Perkins Plaza. Cinema World opened in August 1973 to replace the outdated downtown theater previously located at 211 West Market Street. Cinema World had four theaters, each one housing three hundred seats. The cinema was climate-controlled, with a huge concession stand out front.

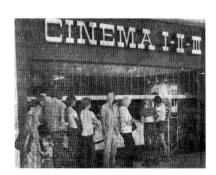

It even showed X-rated films when it first opened, but it quickly ditched that concept for obvious reasons. Cinema World was a part of the Armstrong Theaters company out of Pittsburgh. It had been extremely profitable in the area since day one, so when it was announced that Sandusky Mall was being built, it decided to open up a bigger, second location inside the mall.

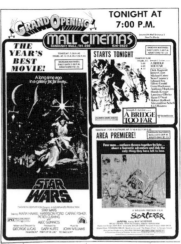

Left, top: The Perkins Plaza Cinema rendering, 1972. *Left, bottom*: Mall Cinema interior, 1977. *Sandusky Library*. *Right*: Opening-night movie screening, July 6, 1977. *Sandusky Library*.

The Mall Cinema opened on July 6, 1977, bringing three new screens to the area. The biggest theater contained six hundred seats; the second, five hundred seats; and the third, four hundred seats. On the first night, a Wednesday, the theater ran three movies: *A Bridge Too Far*, *Sorcerer* and the iconic *Star Wars*. What are the odds that the first movie to debut at the Mall Cinema would go on to become one of the biggest movies for a generation?

By the late 1980s, the theater industry was becoming big business. Summer blockbusters were starting to become more commonplace than ever before. Screens were selling out more often than not. One of the reasons for this boom was the explosion of VCR sales throughout the 1980s. In 1985, one local business owner made $1 million from his video rental store. People found it more convenient to rent a movie instead of going to the drive-in or to the cinema. Since so many people rented movies, the demand for newer, bigger and better blockbusters took hold throughout the decade. And who could blame them, with hit franchises like *Ghostbusters*, *Rocky*, *Teenage Mutant Ninja Turtles*, *Batman*, *Dick Tracy*, *Gremlins*, *Back to the Future* and more dominating box offices by 1990.

As the decade came to a close, Cinema World Inc. announced that it would be constructing a new movie theater behind the mall in 1989. There had been amazing advancements in the industry since the Mall Cinema was built, and it was time for an upgrade. The new theater would have eight screens with better projectors, surround sound capabilities, a

bigger concession stand, an arcade room and a whopping 2,400 seats per theater.

Before the ink was dry on Cinema World's press release, another cinema announced that it was coming to the Sandusky area as well. Cinemark USA, based in Dallas, Texas, intended to build a ten-screen theater behind the new Park Place Plaza. The theater would be decked out with THX audio systems, chairs with cup holders and a video arcade.

With both cinemas vying for the upper hand, it was a race to the finish. In November 1990, both Cinema World and Cinemark were able to open within a week of each other, with Cinema World beating the newcomer to the punch. Sandusky now had four theaters with a total of twenty-seven movie screens. Having so many cinemas operating in one town was quite amusing. Since theaters were not able to show the same movie in competing cinemas, the battle to gain movie rights to some of the biggest blockbusters was fierce, especially when titles like *Jurassic Park*, *Batman*, *Independence Day*, *Star Trek* and other big-name movies were released. As the two newest cinemas battled on, the two older Cinema World locations were reserved for older movies that had rotated out of the bigger theaters, at steep discounted prices. Unfortunately, this business model wasn't very profitable, and the Perkins Plaza location closed in March 1991, followed by the Mall Cinema on September 30, 1993.

Last movie screening, September 30, 1993.

After the Mall Cinema closed, the retail spot was occupied by many buffet-style restaurants that sprang up one after another. Old Country Buffet took over in 1994, followed by Hometown Buffet in 1997, Chinese City Buffet in 2003 and Eastern Chinese Buffet in 2009.

590: RADIO SHACK (1977–2017)

Radio Shack was no stranger to Sandusky, having previously been located downtown on Jackson Street. This company out of Boston, Massachusetts had over 4,200 stores at the time. Radio Shack moved into the mall just in time for the grand opening. This 2,300-square-foot electronic gadget store carried stereos, music systems, radios, tape recorders, CB radios, wires and antennas in all shapes and sizes. Radio Shack was always on

the cutting edge of electronics, especially when it came to computers. Unique to the storefront was the architecture, which feature black wood trim around a white backer wall. This feature remained until the late 1990s, when the black was painted white to give the storefront a more uniform, updated look.

As early as 2015, Radio Shack began running into major financial problems. The company was late on payments and became delisted from the stock market. That February, it filed for bankruptcy and struggled over the next two years to stay afloat in the marketplace, but it was just too much. The company filed for Chapter 11 bankruptcy a second time in March 2017, causing the retail chain to finally close.

600: MONTGOMERY WARD (1976–86); SEARS (1986–2016)

Montgomery Ward was the mall's second anchor store to be built. It was located on the south side of the mall. Construction began in December 1975. Ten months later, the store held its grand opening on October 21, 1976. The company was founded in 1872 and had the distinction of being the oldest national mass-merchandising firm in the country, with 438 locations in operation. The Sandusky store utilized ninety-five thousand square feet of space, with departments including furniture, carpeting, clothing, sporting goods, appliances, electronics, shoes, a beauty salon and even an attached twelve-bay auto center. There was room for an additional 3,700-square-foot lawn and garden center outside. Montgomery Ward was the first company to offer a catalog, in 1872. The company carried forty thousand items in its stores; another sixty thousand items were found only in the catalog.

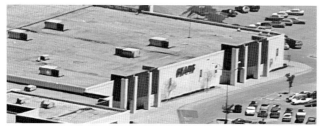

Middle: The Sears sign is raised in 1986.

Bottom: Sears anchor store exterior, 1991.

After a decade of operation in the mall, the company hit hard financial times. The catalog division was closed in 1985, and it began remodeling all profitable stores and closing underperforming ones. This initiative closed the Sandusky location on February 15, 1986.

As soon as it was publicly announced that Montgomery Ward was closing, Sears made it known that it would be taking over the space. Sears left the Perkins Plaza and reopened in the mall that July. Sears's grand opening celebration went off without a hitch, and the store thrived for many years. In 1989, it implemented a new department, Brand Central, to expand and update the home appliance and electronics sections. As Sears rolled into 2010, the company was no longer showing a profit. The competition was fierce, and the company lost $11 billion from 2011 to 2016. In 2016, the Sandusky location closed. Hundreds more Sears locations closed in 2017. In 2018, the company went belly-up and filed for Chapter 11 bankruptcy.

KIOSKS

K2: Frontier Fruit & Nut (1977). Seller of bulk candy and nuts.

K3: Time Squared (1977). A watch repair shop.

K4: Things Remembered (1977). A kiosk for engraved, personalized gifts.

K6: Flowerama (1977). Seller of fresh-cut flowers and bouquets.

K7: Mall information booth (1978).

K8: Lick Skillet (1978). Seller of copper, Indian and turquoise jewelry.

K10: Cash for Gold (1980). Pawnshop kiosk for jewelry.

K12: Vitamin World (1985). Vender of vitamins.

K12: Chez Chocolate (1979). Store offering chocolate-covered treats.

K20: Four Star Sports (1977) Sports branded apparel & jacket lettering.

K21: Leather by Sierra (1977). Leather goods seller.

K24: Children's Portraits (1977). Store specializing in children's portraits and family photos.

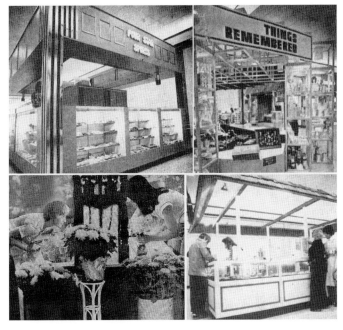

Kiosks around the mall include Four Star Sports (*top left*), Things Remembered (*top right*), Flowerama (*bottom left*) and Lick Skillet (*bottom right*). *Sandusky Library.*

4

THE 1980s AND BEYOND

In the 1980s, the Sandusky Mall really hit its stride. The $20 million gamble had paid off handsomely, as hundreds of millions of dollars in revenue passed through its stores. If you wanted to lease a space in the mall, the amount it charged was around $0.22 per square foot a month, so you do the math. Smaller stores generally signed five-year leases; bigger stores signed fifteen- to twenty-year leases. In 1984, the mall came very close to having 100 percent tenant occupancy. It was only one short when Charlie Chan's closed down days before that happened. The mall eventually did reach 100 percent occupancy, but only in a fleeting solar eclipse–like fashion later that decade.

As Cedar Point began adding new attractions to its park throughout the 1980s and '90s, the mall was able to piggyback off the increased tourism. As for the downtown area, it never was able to become as big as it used to be. The last of the big department stores, LaSalle's and Jupiter, were able to hang on until the end of the 1980s before closing up shop.

In 1982, the mall decided to make room for a fifth anchor store. It brought in BEST Products and anchored it around the back of the mall.

As for the other anchor stores, Halle's ended up closing in 1982, to be replaced by Elder Beerman. Montgomery Ward went belly-up in 1986 and was quickly replaced by Sears, which finally left the Perkins Plaza after twenty years. The spot it left behind was filled by Big Lots in 1987.

One of the more interesting shopping trends that occurred later in the decade was a result of the Cleveland Browns making it to the NFL playoffs.

Everyone had Super Bowl fever during the 1987–89 seasons, causing Sears to have massive Ticket-Tron sales. Three hundred people lined up for tickets for the big game against the Denver Broncos. "This is the biggest turnout we've ever had," said customer service manager June Ross. Tickets sold out in under an hour; over two hundred people were turned away. Stores selling Browns merchandise saw a huge spike in sales. Koenig Sporting Goods, May Co., J.C. Penney, Buckeye & Wolverine Shop and others sold out within hours of getting their shipments.

In the summer of 1988, the mall decided to throw an end-of-summer celebration for the community in the parking lot. The mall's marketing director first proposed a four-day barbeque ribs festival, but those plans slowly morphed into a festival for all ages with daily concerts and polka dancing. It was an event with many charity-raising opportunities, too. It was the only time in the mall's history that a summer celebration was held, and it was attended by over forty thousand people.

THE MILAN ROAD COMPETITION

By the end of the 1980s, other developers began eyeing Milan Road as a potential retail hub and slowly began building their own plazas there. This brought in fierce competition for the mall. The Park Place Plaza, built in 1989, brought in Walmart to compete with Kmart, Toys-R-Us to compete with Circus World, Phar-Mor to compete with Rite-Aid, Service Merchandise with BEST Products and Cinemark Theater with the Mall Cinema.

The second development to compete with the mall was the Lake Erie Factory Outlet Center, built in 1989 and located just outside of town off

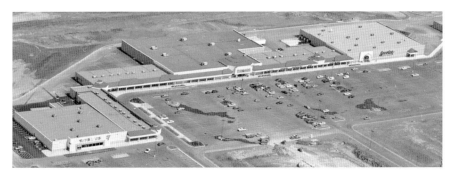

Park Place Plaza with stores including anchor stores Toys R Us, Phar-Mor and Service Merchandise, 1990. *Sandusky Library.*

The Outlet Mall gets ready to open for its grand opening celebration. *Sandusky Library*.

of Mason Road. Over forty stores opened there the first year, including Just*Pants Outlet, Izod, Manhattan Clothing, S&K, What on Earth and Toy Liquidators. The outlet center was a big draw in the summer, but once the winter months took hold, attendance plummeted like a rock. No one wanted to travel such a great distance for lower prices when there were so many stores in town. Many of the outlet's tenants signed five-year lease agreements. Once those leases were up, everyone left, creating a ghost town. In 1997, the owners put the outlet center on the auction block and sold it for $2 million, even though it was appraised at $14 million.

By the mid-1990s, big-box stores began dominating the retail landscape and pushing out the smaller, low-rent stores. Many shopping plazas began springing up on Milan Road, including the heavyweight Meijer in 1995. These new shopping centers were cutting into the Sandusky Mall's profit margin.

Huge department stores closed, like Woolworth in 1993, followed by BEST Products in 1997. Hills Department store tried to stave off closure by implementing a $600,000 remodeling project to update the store. Entire departments were rearranged, and the main doors were placed on the corner of the building. "In terms of merchandise, we're offering very much the same. The difference is in the way we're displaying it," said a Hills spokesman. Unfortunately, the remodel wasn't enough to save the store. Four years later, it filed for bankruptcy. Ames briefly took over in 1999, but it, too, was hit with financial hardships and closed in early 2001.

The Kmart Plaza was also dealt a death blow starting in the 1990s. Kmart underwent a huge remodel in 1992. On the inside, the fondly remembered Kmart Café was remodeled to make way for a Little Caesars pizzeria. A second remodel occurred in 1999 that rearranged the entire layout of the store. This wasn't enough to keep the store afloat, and in January 2003, the company filed for Chapter 11 bankruptcy and closed 326 underperforming locations, including the Sandusky store. Pick N Pay also ran into financial troubles and closed in 1990. Finest reopened in its spot two weeks later and then rebranded in 1999 as Tops. It remained there until Target replaced Kmart in 2005.

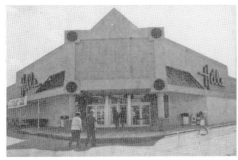

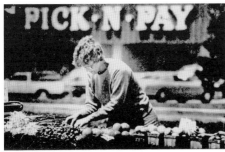

Top: Hills (*left*) reveals the new side entrance, which turned into Ames (*right*) in 1999. *Sandusky Library. Bottom*: *Sandusky Library. Bottom*: Pick N Pay was replaced by Finest in 1990 and turned into Tops in 1999.

As the mall marched toward the new millennium, it began to shed its 1970s retro-style architecture. Changes began as early as the late 1990s. The aging stained-glass lighting fixtures were removed in favor of plain white fixtures. All the indoor light posts were removed, as were the wood-paneled walls. In 2004, skylights were cut into the ceiling of the concourse to increase lighting into the building; the water fountains were turned off, emptied and filled in; and in 2010, over sixty thousand feet of heavy-duty carpet was laid down throughout the concourse to replace the aging tile.

Gone were the neon lights and retro storefronts. Replacing them were trendy teen-oriented stores like American Eagle Outfitters, Hot Topic, Pac-Sun and Aeropostale. Slowly, the cookie-cutter storefronts found in every other mall across the country had now taken over the Sandusky Mall. Every trace of the 1970s mall was now standing in a faint shadow of what had been. It was truly the end of an era.

As I write this book, the mall is going through some of its most drastic changes yet in 2020. When I look back at the mall of yesteryear, it teaches us the painful lesson of how impermanent is the foundation to the world we live in. This lesson is taught to us through many world religions and

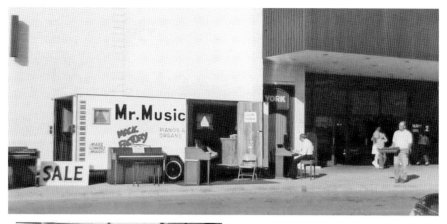

Above: Mall entrance #2 in the mid-80s during Mr. Music's sidewalk sale. Note the extra entrance to York Steakhouse from the street. *Courtesy of Dot Bliss*.

Left: The mall interior during the 1990s, with all the fancy lighting fixtures now removed and the fountains emptied. *Sandusky Library*.

helps remind us to not take things for granted, because one day, everything that is familiar will change and vanish. So don't take anything for granted.

It's interesting how a place most of us never gave a second thought about has become nostalgic to a whole generation. It was a place we all visited on a regular basis, yet it's only when we sit back and reflect what has been lost over time that we actually miss the echo of the memory left behind. Generations before us remember downtown as their main shopping hub. Generations after us will remember all the other stores along Milan Road as their main shopping experience. As long as we honor the shadow of what remains, the 1970s Sandusky Mall will live on in our minds, hearts and this book forever.

BIBLIOGRAPHY

Cleveland Plain Dealer. "Some Malls Go to Court With Halle's." February 1, 1982.
Elyria (OH) Chronicle Telegram. "Grand Opening at Area Mall." March 17, 1977.
———. "Mall's Pushing One Stop Shop Concept." April 22, 1980.
———. "Sandusky Mall Plans Announced." December 29, 1971.
———. "Storm Damage Repaired." February 15, 1978.
———. "Tornado Mauls Mall." July 1, 1977.
"NewspaperArchive | 15,494 Historic Newspaper Archives." *NewspaperArchive | 15,494 Historic Newspaper Archives*, https://newspaperarchive.com
"Sandusky Library." *Sandusky Library*, https://www.sanduskylib.org.
Sandusky Digital Archives, Sandusky Ohio.
Sandusky Register. "Action Hardware." April 18, 1977.
———. "All Land for Sandusky Mall Acquired." April 4, 1973.
———. "Amsel's Shoe Shanty Coming Soon." January 11, 1979.
———. "Angelo's Hiring." August 22, 1982.
———. "Another Mall Tenant Announced." June 1, 1976.
———. "Area Fans Going Wild for the Browns." January 11, 1987.
———. "Astro Print." December 3, 1976.
———. "Athlete's Foot Woo's Cleared Up." July 11, 1992.
———. "Athlete's Foot." May 31, 1979.
———. "Attitudes Closed Universe." January 10, 1988.
———. "Baskin Robbins." October 28, 1976.
———. "Beat Goes on at Crane." October 2, 1983.
———. "Bernard Wigs." June 6, 1977.
———. "BEST." September 23, 1982.
———. "Best Products to Open in Fall." February 15, 1982.
———. "Best Store Closing." October 8, 1995.
———. "Blizzard." January 27, 1978.
———. "Borders Plans Store for Sandusky Mall." April 18, 2007.
———. "Brooks Fashions." November 16, 1976.

———. "Brook's Going Out of Business." June 1, 1994.

———. "Buffet to Open at Mall." February 16, 1994.

———. "Buried Alive." January 24, 1978.

———. "Business Ledger—Booklein." October 7, 1977.

———. "Cafaro Co. In Mall Business From the Beginning." March 15, 1977.

———. "Captain Potato Chips." December 11, 1976.

———. "Car Show." February 5, 1977.

———. "Caryl Crane Store Sold." September 2, 1983.

———. "Caryl Crane to Open Children's Theater." November 6, 1985.

———. "Cedar Point Buys Seven Seas Gift Shops." February 15, 1978.

———. "Celebrate the Sandusky Mall Merchants." March 15, 1977.

———. "Chamber's Sets Projects." May 27, 1970.

———. "Changing Scene at Mall." March 13, 1983.

———. "Chan to Visit." November 25, 1977.

———. "Charges Filed." January 14, 1982.

———. "Cheryl's Cookies." September 7, 1985.

———. "Cinema's Opening." July 8, 1977.

———. "Cohn Store." May 4, 1973.

———. "Coming Soon, Diamond Mens." July 5, 1977.

———. "Company Philosophy Cited in Pries Closing." February 3, 1982.

———. "Corporate Sales." September 18, 1983.

———. "Court Docket." July 18, 1980.

———. "Crane, Penney Don't Regret Mall Move." February 13, 1979.

———. "Creature on Display at Mall." July 13, 1977.

———. "Dealing the Tops Card." May 19, 1999.

———. "Developers of Snadusky Mall Expect Construction in Spring." October 2, 1972.

———. "Development Near Mall to Be Revealed." January 10, 1987.

———. "Down and Outlet." October 23, 1994.

———. "Downtown Development Essential." October 31, 1975.

———. "Duke and Duchess." March 4, 1977.

———. "Early Start Seen for Sandusky Mall." April 3, 1974.

———. "18 New Tenants Swell Sandusky Mall Total to 53." October 23, 1976.

———. "Eight Movie Screens to Open Near Mall." November 16, 1989.

———. "Elder-Beerman Opens in Mall Mar 1." February 5, 1983.

———. "Elder-Beerman to Hire 100 at New Mall Store." October 21, 1982.

———. "End of an Era." December 31, 1993.

———. "Entire Halle Store Chain to Close." January 27, 1982.

———. "Factory Outlet Mall a Mecca." March 25, 1989.

———. "Few Changes in Lineup at Mall." March 25, 1984.

———. "Financial Woes Close Cohn's." March 27, 1979.

———. "Fisk Previews Mall Proposal." November 27, 1969.

———. "5 New Stores Lined Up for Mall." February 19, 1982.

———. "Former Employees Opening Penney Store at Mall." May 1, 1976.

———. "Gap Map." February 24, 1977.

———. "General Nutrition Center." March 3, 1977.

———. "Gray Drug's New Look." July 30, 1969.

———. "Growth Is the name of the Game in Perkins." May 28, 1978.

———. "Gutman's Buys Preis Stores." November 15, 1981.

———. "Gutmans May Close." August 28, 1985.

———. "Gutmans Won't Reopen." October 3, 1985.

———. "Halle Bros. to Open Store in Local Mall." October 19, 1979.

———. "Halle's Countersues." February 2, 1982.

———. "Halle's Future Still Undecided." January 19, 1982.

———. "Halle's Shutters Its Stores at the Mall." February 15, 1982.

———. "Halle Store Part of Purchase." November 18, 1981.

———. "Haunted House at Mall." October 14, 1980.

———. "Health-o-rama Planned at Mall." January 26, 1977.

———. "Hickory Farms Closing." July 10, 1988.

———. "Hill's New Look." July 2, 1994.

———. "Hills—3 More Stores." August 13, 1963.

———. "Holiday Shoppers Bring Cheer to Local Merchants." December 1, 1976.

———. "Holman's Jewerly." June 17, 1984.

———. "Holman's Says Hello." October 13, 1977.

———. "Hoty's Opens Mall Store." December 15, 1978.

———. "House of Fabrics Going Out of Business." November 30, 1994.

———. "House of Vision Court Filing." December 28, 1981.

———. "How Woolworth Began." November 16, 1966.

———. "It's Halloween." October 29, 1982.

———. "It Was a Celebration." February 28, 1979.

———. "JayCee's to Open Haunted House." October 10, 1980.

———. "JCPenney Auto Center to Close in Spring." February 2, 1983.

———. "JCPenney Rising." June 20, 1975.

———. "Jeweler Quits Mall." April 6, 1977.

———. "Karmelkorn." June 17, 1989.

———. "Kaufmann's Become Macy's in 2006." July 30, 2005.

———. "Kay Jewelers New Store Opening." August 26, 1977.

———. "King Sized Kmart." April 14, 1975.

———. "Kmart Grand Opening Scheduled." June 27, 1975.

———. "Kmart Looking for New Location." August 29, 1973.

———. "Kmart–Mall Developers Conferring New Location." January 23, 1974.

———. "Kmart Permit Tops Perkins Construction." November 14, 1974.

———. "Lack of Rent Shuts Down Mall Eatery." April 14, 2006.

———. "Laws Hamper Exotic Pet Sales." November 9, 1979.

———. "Lawsuits." October 7, 1981.

———. "Lawsuit to Block Mall Dismissed." November 18, 1975.

———. "Lay Your Hands on a New Car." June 25, 1977.

———. "Legal Notice, Slumber World." April 13, 1987.

———. "Legals." February 14, 1972.

———. "Lennon Records Sell Out." December 10, 1980.

———. "Lerner Shops." March 2, 1977.

———. "Let Sun Shine to Darken Pale Skin." March 30, 1986.

———. "Liquidation Sale." March 20, 1992.

———. "Local Revco Festival Is Just the Berries." July 7, 1978.

———. "Local Store invest $150,000 in New Image." August 8, 1984.

———. "Local Women Operate Beauty Salon." October 20, 1976.

———. "Look at the Crowds." July 31, 1970.

———. "Mail Station Set up at Mall." December 10, 1977.

———. "Mall Banking." June 6, 1976.

———. "Mall Blocked." June 5, 1974.

———. "Mall Celebrates Second Anniversary." March 17, 1979.

———. "Mall Chamber Meet." May 7, 1974.

———. "Mall Changes in 1987." March 20, 1988.

———. "Mall Death Robbery Motive Questioned." February 29, 1988.

———. "Mall Developer to Build Sewer." August 13, 1976.

———. "Mall Drops Market." June 1, 1984.

———. "Mall Meeting." May 19, 1970.

———. "Mall Opening." March 16, 1977.

———. "Mall Opens Summer Celebration." August 25, 1988.

———. "Mall Owners Hunting for New Restaurant Bar." August 14, 1985.

———. "Mall Owners Seek Eviction of Tenant." October 19, 1979.

———. "Mall's First Year has Not Been Dull." February 18, 1978.

———. "Mall's Musicland Carries Top Sounds." February 18, 1978.

———. "Mall Stores Doing Business." April 14, 1977.

———. "Mall Store to Open in July." June 6, 1982.

———. "Mall Sues Halle's for 15 Million." February 1, 1982.

———. "Mall Wall Drops." January 27, 1978.

———. "Mall Will Be Built." March 8, 1973.

———. "Mall Will Lose Woolworth's." September 24, 1993.

———. "Mall Work Predicted by July 1." May 6, 1974.

———. "Maurauding Monsters." August 26, 1993.

———. "May Co. Construction Underway." November 16, 1977.

———. "May Co. Is Now Kauffman's." January 23, 1993.

———. "May Company Opens." March 2, 1979.

———. "May Company Preview Party." January 26, 1979.

———. "May Co. Steps in With Financial Heavyweight." November 16, 1986.

———. "Media Preview of JCPenney." April 24, 1976.

———. "Merchants Fear Smaller Piece of Pie." May 6, 1993.

———. "Milan Firm Fabricates Mall Steel." May 23, 1975.

———. "Montgomery Ward." October 20, 1976.

———. "Montgomery Ward to Close." November 1, 1985.

———. "More Movies at the Mall." February 10, 2010.

———. "MotherCare." June 21, 1977.

———. "Mr Bulky's." August 31, 1988.

———. "Mr Music." December 30, 1989.

———. "Naturalizer Grand Opening." November 17, 1977.

———. "New Cohn's Dept Store Offers Spacious Shopping." August 24, 1977.

———. "New Jeweler." December 12, 1984.

———. "New Store." June 30, 1982.

———. "New Store at Mall to Hire 40." February 17, 1982.

———. "Nobil Shoes." November 5, 1976.

———. "Notice of Dissolution." November 25, 1986.

———. "No Treat Here." October 28, 1978.

———. "Ohio Continues to Lead Nation in Road Building." November 1965.

———. "1 Hour Photo Strives for Speed and Quality." March 17, 1985.

———. "Only 1.00." September 2, 1988.

———. "Opening of Banc Ohio Branch." September 6, 1978.

———. "Opening of New May Co in Mall Forces Delay." July 25, 1977.

———. "Own Your Own Petland." February 17, 1979.

———. "Payless Shoesource." February 1, 1984.

———. "Pearle Vision." March 14, 1977.

———. "Perkins Commission Backs Zoning Change." February 18, 1975.

———. "Perkin's Ok's New Zone Code." July 23, 1980.

———. "Perkins Ok's Zoning." June 18, 1974.

———. "Perkins Plaza in Twp." December 30, 1972.

———. "Perkins Shopping Center Plans for '88 Opening." August 26, 1987.

———. "Perkins Township Construction." January 1, 1976.

———. "Pick-n-Pay Construction Starts at Mall Site." October 3, 1975.

———. "Pick-n-Pay to Close Aug 13." August 5, 1988.

———. "Piecing Together Mall" June 6, 1976.

———. "Playing Santa Full Time Job." December 14, 1980.

———. "Police Blotter." June 17, 1981.

———. "Police Still Looking for Clues." March 1, 1988.

———. "Poor Sales Doomed Toy Store." January 7, 1992.

———. "Precious Good Luck Stone." October 24, 1977.

———. "Ragazza." July 7, 1977.

———. "Record Shop Plans November Opening." October 13, 1976.

———. "Retail Management." July 4, 1982.

———. "Richmond's Opens in Mall." March 8, 1978.

———. "Rite Aid Store Closings." January 12, 1994.

———. "Rivet Jeans." May 12, 1977.

———. "Robert Hall." February 5, 1977.

———. "Rogers Jewelers." October 27, 1976.

———. "Royal Optical." February 1, 1985.

———. "Rumors Dismissed." June 18, 1977.

———. "Sandusky Diary." April 21, 1970.

———. "Sandusky Group Hits Proposed Sewer Fees." October 20, 1975.

———. "Sandusky Mall Eyed by Spring." November 26, 1974.

———. "Sandusky Mall in Fifth Year, New Stores Replacing Old." March 14, 1982.

———. "Sandusky Mall Information." January 11, 1979.

———. "Sandusky Mall Opening Wed." December 1, 1977.

———. "Sandusky Mall Opens Wed." November 16, 1976.

———. "Sandusky Mall Sewers to Be Financed." February 7, 1975.

———. "Sandusky Mall Still Planned." May 5, 1972.

———. "Sandusky Mall Stores Open for 1st Time." February 1, 1978.

———. "Sandusky Mall Sues Halle's Store Owners." January 31, 1982.

———. "Sandusky Plaza Celebration Underway." November 2, 1956.

———. "Sandusky's Caryl Crane Celebrates 30 Years." April 24, 1976.

———. "Sandusky's Not Sick." January 16, 1968.

———. "Santa Making His Christmas List." November 18, 1977.

———. "Scotto's Pizza Breakfast." September 25, 1980.

———. "Sears New Home Brings New Look." July 18, 1986.

———. "Sears to Move to Sandusky Mall." November 4, 1985.

———. "Seven Seas Gift Shop." March 30, 1967.

———. "Several New Screens Planned in Perkins." May 3, 1989.

———. "Shopping Center." March 8, 1972.

———. "Shopping Mall." December 28, 1971.

———. "Smaller Shops Move In, Out at Mall." March 15, 1987.

———. "So Fro Fabrics." February 15, 1977.

———. "Some Mall Stores Open." January 30, 1978.

———. "Standard Sportswear." June 30, 1977.

———. "Store Closing." October 11, 1992.

———. "Store Shuffle." January 12, 1994.

———. "Stores Report Star Wars Toy Sales Taking Off." December 9, 1978.

———. "Suit Alleges Firm Destroyed Land." November 5, 1974.

———. "Suit Won't Stop Construction." June 13, 1975.

———. "Talks Underway for Halle's Spot." January 28, 1982.

———. "A Taste of Italy Comes to the Mall." June 20, 2002.

———. "Thefts from Holman's." December 3, 1981.

———. "Thefts from Holman's." December 3, 1982.

———. "There's More to Opening a Retail Store." April 3, 1976.

———. "36 Stores Sign Leases to Go into Mall." July 17, 1976.

———. "Thousands Mill Around Mall." November 18, 1976.

———. "Through the Years." April 7, 2002.

———. "Today Marks 35 Years of Crane." October 8, 1980.

———. "Tornado Damage Mall." July 1, 1977.

———. "Tornados Rip Area." July 1, 1977.

———. "Toy Store's Mall Departure Disrupted." January 5, 1988.

———. "Two Looking at Vacant Mall Locations." December 11, 1985.

———. "2 Million Dollar Complex Slated." August 25, 1965.

———. "Two More Stores Open Thursday." November 25, 1976.

———. "Two More Stores to Open at Mall." November 25, 1976.

———. "2 Stores Plan Mall Outlets." November 12, 1976.

———. "Universe Critics Courageous." January 21, 1988.

———. "WaldenBooks." October 25, 1976.

———. "Wards Building in Mall." January 23, 1976.

———. "Wards Shuts Doors for Last Time." February 1, 1986.

———. "Watch It Witch! Santa's Hot on Your Trail." October 28, 1978.

———. "Water Pipe Breaks at Mall." December 17, 1989.

———. "Wig Customers Are Cancer Patients." November 9, 1983.

———. "Wigs Available Again at Chic Wigs." August 5, 1981.

———. "Woman's Clothes Shop Set for Mall." May 1, 1986.

———. "Workmen Continue Construction." November 16, 1976.

———. "Work Starts on Sandusky Mall." August 20, 1974.

———. "Would Bobby Riggs Hustle His Own Mom?" March 17, 1978.

———. "York Choices." April 24, 1985.

———. "York Steak House." May 31, 1977.

———. "Zondervan's Family Bookstore Offers So Much More." August 5, 1981.

———. "Zoners OK 50-Store Outlet." February 18, 1988.

———. "Zoning Changes Okay'ed." March 22, 1972.

———. "Zoning Report." July 16, 1981.

PHOTO CREDITS FOR CHAPTER 3

Page 51: Top: *Sandusky Library*. Bottom: *Linda Howell*.

Page 52: *Chris Bores*.

Page 54: Top: *Linda Howell*. Bottom, inset: *Sandusky Library*.

Page 55: *City of Sandusky*.

Page 56: Left: *Sandusky Library*. Right: *Linda Howell*.

Page 57: Top: *Diamond Men's Shops*. Bottom, left: *Sandusky Library*. Bottom, right: *Linda Howell*.

Page 58: *Julie Hamilton*.

Page 59: *Julie Hamilton*.

Page 61: *Paul Smith*.

Page 62: *Sandusky Library*.

Page 63: *Sandusky Library*.

Page 64: *Sandusky Library*.

Page 65: *Sandusky Library*.

Page 66: Bottom, left: *Rob Shiff*. Bottom, right: *Sandusky Library*.

Page 67: *Sandusky Library*.

Page 68: *Linda Howell*.

Page 69: Top: *Linda Howell*. Middle: *Sandusky Library*. Bottom: *Sandusky Library*.

Page 70: *Sandusky Library*.

Page 71: Top, left: *Sandusky Library*. Top, right: *Jayson Schlechty*. Bottom: *Jayson Schlechty*.

Page 72: *Sandusky Library*.

Page 73: *Sandusky Library*.

Page 74: Top: *Sandusky Library*. Bottom: *Perkins High School Alumni*.

Page 75: *Paul Smith*.

Page 76: *Paul Smith*.

Page 77: Top: *Paul Smith*. Middle: *Sandusky Library*. Bottom: *Sheila Franklin*.

Page 78: *Linda Howell*.

Page 79: *Sandusky Library*.

Page 80: Top, left: *Sandusky Library*. Top, right: *Larry Rogers*. Bottom insets: *Sandusky Library*.

Page 81: Top: *Sandusky Library*. Middle: *Paul Smith*. Bottom: *Chris Bores*.

Page 82: *Sandusky Library*.

Page 83: Top, left: *Paul Smith*. Top, right: *Sandusky Library*. Bottom inset: *Sandusky Library*.

Page 84: Left: *Linda Howell*. Right: *Sandusky Library*.

Page 85: *Sandusky Library*.

ABOUT THE AUTHOR

Author Chris Bores in the north hallway showing a then-and-now comparison. *Chris Bores.*

Ohio native Chris Bores grew up in Huron and has had a lifelong fascination with history and any historical stories linked to the paranormal. He has been featured on the Travel Channel, Coast to Coast AM, TRU TV, Hardcore Pawn, CBS News, FOX News, *Dayton Ghosts*, the Star 105.5 morning radio show, the 1370 AM morning show, the *Toledo Blade*, the *Toledo Free Press* and the documentary *ATARI: Game Over*. He was YouTube's 55th Most Subscribed Channel in 2010, and his first book, *Ghost Hunting 2.0*, was a best-selling book on Amazon. He is also the first ghost behaviorist.